Art Savvy
Your Private Eye

Understanding Public Art in 5 Easy Pieces
By T.J. Aitken

Published by
Novus Resource Inc.
Holland, MI, USA
Copyright 2013
ISBN-13: 978-1492133490
ISBN-10: 1492133493

To Victoria White,

Who puts up with artistic whim, touchy
technology and perseveres
through every adversity:
Thanks a million

Can I Understand Public Art?

What is an artist looking at when they make art? If Art has been a little mysterious, boring, or seems silly, you will benefit from *Art Savvy* tools for understanding. If we are to "see" art and judge what makes one work good, another bad, and the occasional one really fine, we need to define terms to think about them. This book is a primer to help you see and compare basic elements. Art Savvy starts your list and organizes the pieces for you. I'm confident that once you have seen elements of good art you will always see them. You will get much more pleasure from looking and seeing. You will become a skilled critic with something to say. Enjoy your new perspective.

Tj. Aitken

About this Book

Art Savvy is a systematic approach to understanding 3D art. Unlike most chaotic writings on art, terms are clearly defined and illustrated. It is designed to answer these questions:

How do you analyze and rate art?
What are the basic elements?
How do you asses them?

Analysis leads to more investigation of, and appreciation for, things formerly not understood. We break down **"Design Elements"** and **"Organizational Principles"** to give an assessment of the graphic composition. We look at many *opposites* to assess the strength of works of art. We clump attributes together and split these into categories to organize our analysis. We define terms and provide *check lists* to prompt thinking. You can do a great assessment if you consider just-

Art Savvy - **The 5 Easy Pieces:**

1. **Design Elements-** Visual grammar, line, shape, form, etc. - definitions & how to see them
2. **Organization Principles-** How are elements arranged and how does this affect the concept?
3. **Style-** Is this work related to other groups of work or does it have its own strength of design?
4. **Technique-** How were methods and materials were used to impact the concept?
5. **Concept-** What is this piece about? What major themes and elements is it built on?

A field Guide to Artwork explaining:

Design Elements **Organization Principles** **Style** **Technique** **Concept**

Reading *Art Savvy*

Visual literacy is the ability to interpret, negotiate, and make meaning from information presented in the form of an image. Visual literacy is based on the idea that art can be "read" and that meaning can be communicated through a process of reading. An aesthetic experience comes from each piece of art unless it is so overused or common that we look right past it.

Aesthetics (or esthetics) is a term derived from the Greek word "aesthesis" meaning "perception," which is the branch of philosophy that is devoted to the study of art and beauty.

Defining Terms: Often art terms are not clearly defined, are used interchangeably and mixed up with other types of analysis. Because art is from a given period and culture, the philosophy behind it, feelings about it and obscure connotations are points of discussion in many books. This can be mixed in with pure assessment of the object of art itself, making for long paragraphs, difficult reading, and confusion. This book will define and delineate terms carefully and use only those that apply to the art object itself. We make no attempt at judgments of relevance, philosophy, spiritual meanings and other ethereal aspects that a work may convey. We ask the question: "What is the basic concept here?" but we stick to pure analysis and leave all judgment to you and the experts.

Illustration format- Words are color keyed to lines on photos. Look for matches to see specific explanations, like the gentle vs. jagged lines in this piece and the direction of gaze.

Assessment techniques
The instructions on how to view aspects on a specific page will help you look good.

What we will not deal with (Though this applies to them as well):
- **2 Dimensional Pictures:** painting, drawing and photographic work. These have many analysis tools. This book's focus is on sculptural and more complex installation works that appear in public venues, and depend much more on form and material than drawing and color.
- **Performance Art**, i.e.: film- video- music – theatrical performance- interactive concept art.
- **Commercial Art-** architecture, industrial, graphic, and landscape design and digital works.
- **ART vs. CRAFT / the validity argument** -We will not attempt to define what is, and is not, valid fine art. You and lots of experts can decide that. We will however give you tools to assess what you see and help you see some of what the artist did in creating the work. We help you decide for yourself what is good and bad art based on more than "I like it" or "I don't get it." With these tools you can create and defend your opinion.

Each page has the 5 tabs at the bottom. **Black lettering** indicates which of the 5 pieces that page covers for easy flip through reference.

A field Guide to Artwork explaining:
Concept Technique Style Organization Principles Design Elements

5 Easy Pieces - Defined

Art Savvy uses five aspects of art for assessment. Each aspect is minimally illustrated and defined for you, so you can go right to the art and explore for yourself, building your own way of seeing. Here are the definitions of the five pieces and why they are here:

Design Elements- The most basic building blocks. We look carefully at 8 of them that pertain to sculpture and public installation. There are many more. Most people understand and have seen tons of explanation on 2D work (color and texture). We leave pictures alone and focus on 3D. This book defines and shows you how to assess these:

Line Shape Form Contour Plane Mass Volume Proportion

Organization Principles- How the artist arranged the elements can be grouped into categories that really help us see them and see how they fit together as a composition. Like a Honda transmission, the elements will mesh together to produce smooth transitions at different levels of intricacy in a good piece. Again there are many more but these eight will give you an excellent start:

Rhythm Balance Movement Emphasis
Order Space Unity Economy

Style- There is so much said in the art world in **the short hand** of "styles" that we need to illustrate what this means to clarify this term. We have included a history chart FYI but we do not need this perspective for graphic analysis. Originality in art will however depend on knowledge of past works. Some artists are so well known, (usually because of originality) that their very name becomes a style. Knowing a bit about the various modern movements (-isms) in the art world helps also with sorting out **concepts**, design themes, and originality. The culmination of **design element** decisions based on **organizational principles** results in a **style**.

Technique- How was this done? What is it made from, how was that stuff manipulated? We look at craftsmanship, construction and finish. The idea of the work has been filtered through an artist's thinking and executed by the hand of the maker. All three coincide in execution technique. The results create our experience with a work of art. If one aspect is weak we notice, especially if we have learned how to "see" and can break them down. The rubber meets the road here and no artist is successful without mastery of technique. It is not as easy as it may appear! That is why they call them Artists.

Concept- Hey, what's the big idea? All art has a concept whether the artist or viewers realize it or not! The statement being made and emotional impact is from the concept. Each work must be assessed for what the artist put in, dealt with, and left alone. Concept is how we determine sophistication and where the interesting cultural references lie. A twist not seen before will amuse and intrigue like good humor does. The ideas behind good works of art will produce unity from individual elements within the other 4 easy pieces. The concept of a work includes its execution **technique**, as well as the graphic **design elements** used with a set of **organizational principles** to produce its own **style.** This is what makes art more than decoration and illustration. There are far too many variations of concept to put into a checklist. Our last section discusses concept art which often shuns the other design elements of aesthetics to focus solely on an idea.

Design Elements Organization Principles Style Technique Concept

Toward Assessment-
Viewing a work of art, and asking what you know about the 5 categories, you can see how an objective assessment will work. You can say a lot without pronouncing your judgment about "like" or "dislike." These tools give you objectivity and will grow your appreciation for what has been done even in pieces you don't like. The more you think about the 5 pieces in artwork the more interesting art is.

Concept | **Technique** | **Style** | **Organization Principles** | **Design Elements**

Design Elements — 8 Basics to Start

Line Shape Form Contour Plane Mass Volume Proportion

Assessing a design requires looking at basic elements (grammar) and seeing how they relate to the composition. We want to look at each element thoroughly, which requires a clear definition. Many terms chosen for this book have multiple meanings in different fields of endeavor. They are defined here for clear viewing of art work and may be slightly different from other uses. They have been illustrated when needed and color-keyed for brevity. There are many more, but these 8 basic building blocks are a good start.

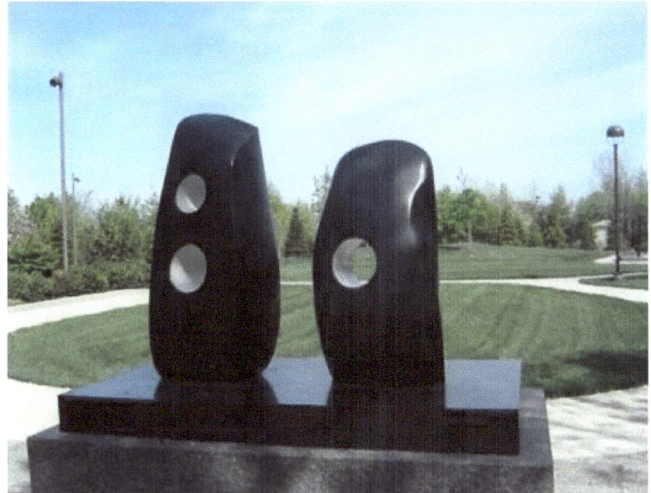

The elements have been assembled by the artist into a design theme. He has selected which ones to focus on and how to apply **organizational principles**. We look at them individually and cross reference them to the organizational principles as a method of assessment. Some works may be heavily dependent on one element and possibly have nothing of others. For most sculpture they all apply. Different ways of organizing them create themes. Common design themes become a style and similar groups may get labeled as a style.

You will discover a greater number of and deeper intimacy between relationships the more you break down and asses a good composition.

Design Elements Organization Principles Technique Concept

Design Elements

Line Shape Form Contour Plane Mass Volume Proportion

Line is so critical that just a few can describe a whole work of art on a napkin! The question: how to see them?
Definition: Any aspect that creates a visual line, like an edge of a form, axis of a form, direction of view, reflection and shadow, series of points or intersections, row or continued series, a path, an outline. Lines may have character and order that produce a mood or reaction.

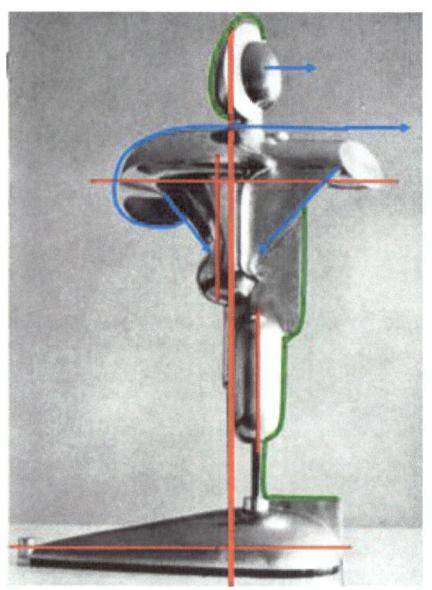 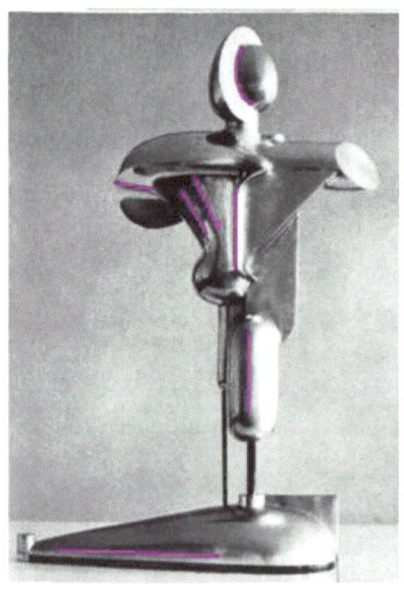 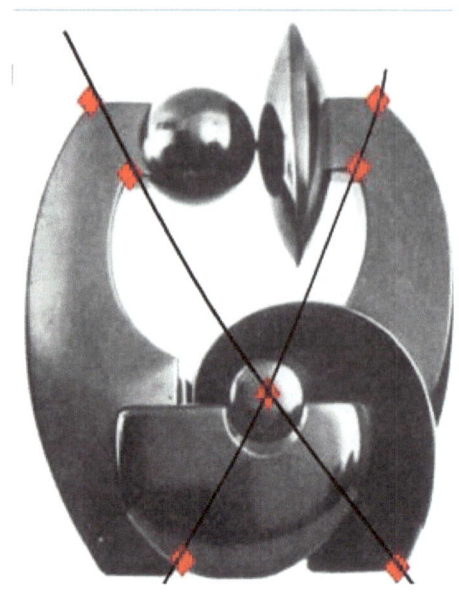

Some implications: flat lines = calmness; wide and fast = boldness; repetitions = order;
flowing curve = restful; angular, chaotic = threatening

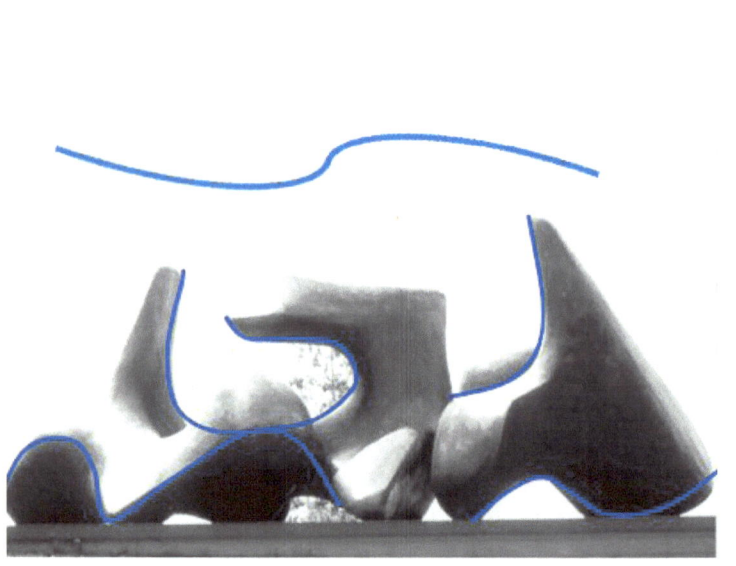 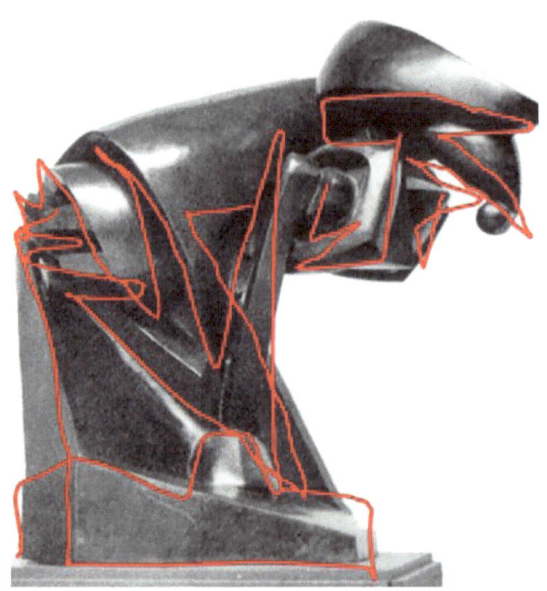

Look at all ways that lines are formed in the work.
Your question- What *are* the lines of this work? How do they relate to the whole?

Concept | Technique | Style | Organization Principles | Design Elements

Design Elements These terms often overlap. We define and separate them for clarity.

Line **Shape** vs. **Form** Contour Plane Mass Volume Proportion

Shape is 2D, has no depth, caused by edge, color contrast, or change in surface value depends on view angle and light source, does not define mass or volume (think silhouette) i.e.: circle, square, triangle, swoosh. It can be theoretical or actual, a view of a form, shadow or negative space. And could be formed by alignments or implied by closure. A shape has character.

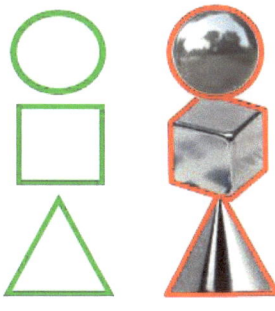

Form is 3 dimensional, having surfaces and planes defining a unit that has depth, mass and volume, i.e.: sphere, cube, egg, lump. A major form may have areas that are appendages or sub forms. Note the forms below create a negative shape almost identical to views of the forms. A form can be open or closed.

Most shapes *and* forms stem from two structural types:
Organic and **Geometric**

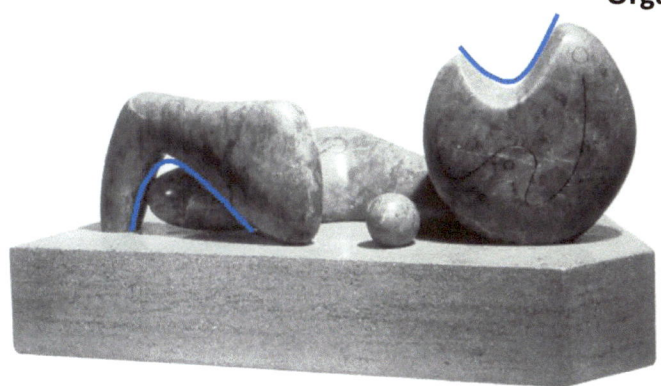

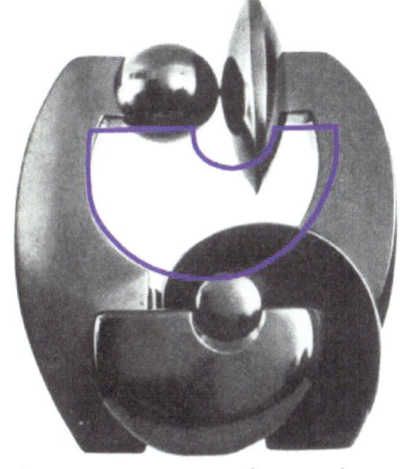

Forms and shapes seemingly grown, eroded, or created by nature, amorphous organic shapes and forms— pebbles, blobs, stains, leaves, hands, bodies, are very hard to describe in geometry yet more easily modeled by hand, without tools. But even flat plates, like the sides of this base, are difficult without a tool.

Crisp geometric constructs— cubes, spheres, ovals, and triangles are seldom seen in nature at the human scale. We create them with careful measurement and tools. Even the surface crowns here are mathematically sweet, creating clean reflection lines.

Design Elements Organization Principles Technique Concept

Design Elements

Line Shape Form **Contour** **Plane** Mass Volume Proportion

Contour is the topography on the forms; the outer edge of a form when viewed from a given position shows a contour. The term has become a verb for creating smooth surface with careful transitions from one patch of common contour to another. For us a unified area of surface is a contour. A sophisticated transition from one to another may produce a single designed contour. It is a description of the surface, but not down to a magnification level that would be called texture. A texture can lay on the contour.

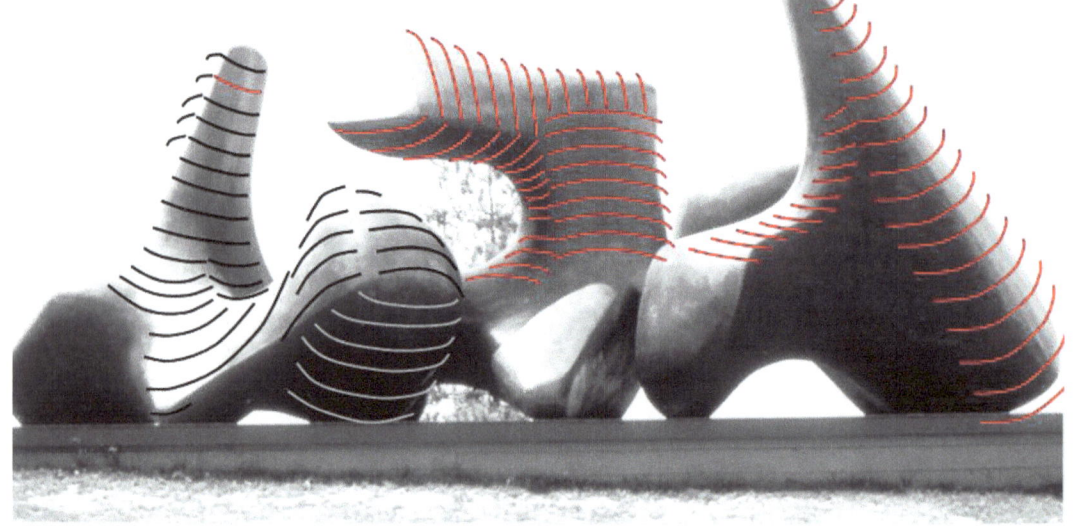

A sphere has the exact same contour in any direction

1. Plane is a continuous theoretical surface, can be defined by actual surfaces or alignment of objects or points. It can be defined by edges. Not necessarily flat. Objects have major and minor planes. Note that all the objects on this base stay within the theoretical planes created by the base's sides. The cut away could be defined by a curving plane, especially if an adjoining object reinforces the phenomenon by being intersected in alignment.

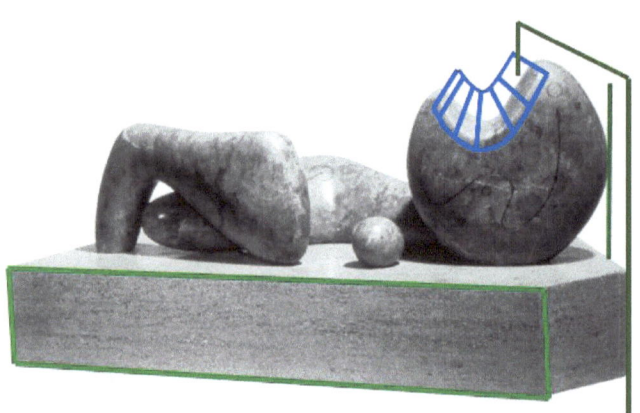

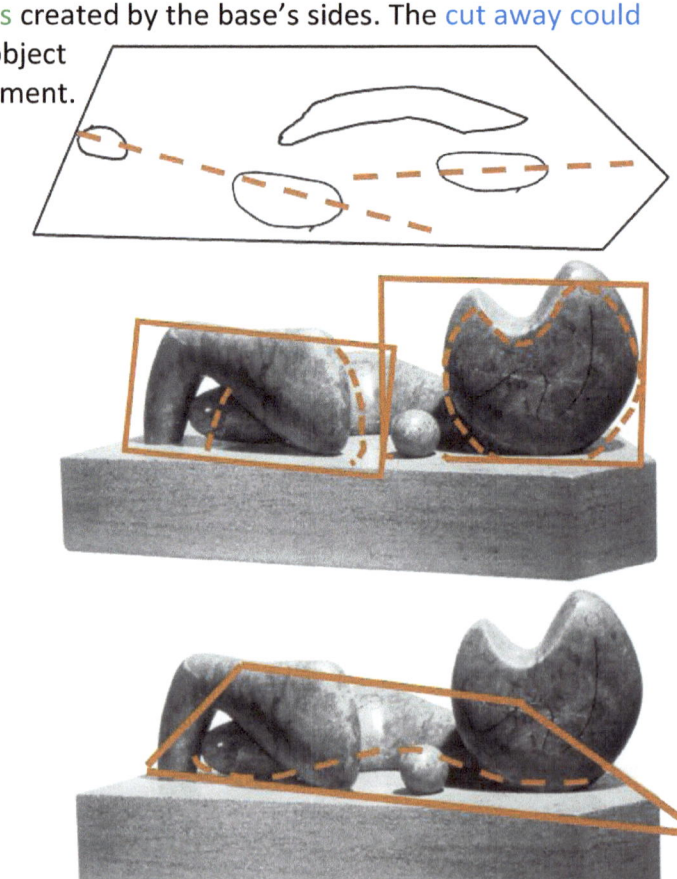

2. Plane of a form's orientation, or how it sits in space as to center line. If you were to cut these forms from blocks of wood you would lay them each out on the plane of axis, and then attach them to this base to get the tilt of that plane. The third object's plane of orientation is horizontal, it is lying down. All three plans just miss the sphere. It has been strategically placed in between them. A sphere has no plane of orientation, only a center point.

Concept Technique Organization Principles **Design Elements**

Design Elements

Line Shape Form Contour Plane **Mass** **Volume** Proportion

Mass is the apparent weight of a form. Size obviously contributes to the sense of mass but the composition; positioning and additional elements like texture on a form can enhance the perception of mass. Juxtaposition to smaller forms will make mass appear greater. Contours that stretch will enhance mass, so will threatening surface lines. Mass is visual weight and not necessarily actual weight. When mass is elevated and separation- it creates tension, our anxiety about collapse increases. Low center of gravity is restful. The form circled is the only one cantilevered in the Moore piece. By itself it would create great tension, but because it is flanked by other forms and placed in the middle we hardly notice. Consider how mass is used in these compositions to create tension, stability, and convey power. Place your hand over the base of these pieces and note the change in stability of the composition. Estimate a mathematical mass value for each form and add them up, or look for relationships. The power conveyed in the portraits below is enhanced by the mass that the heads control.

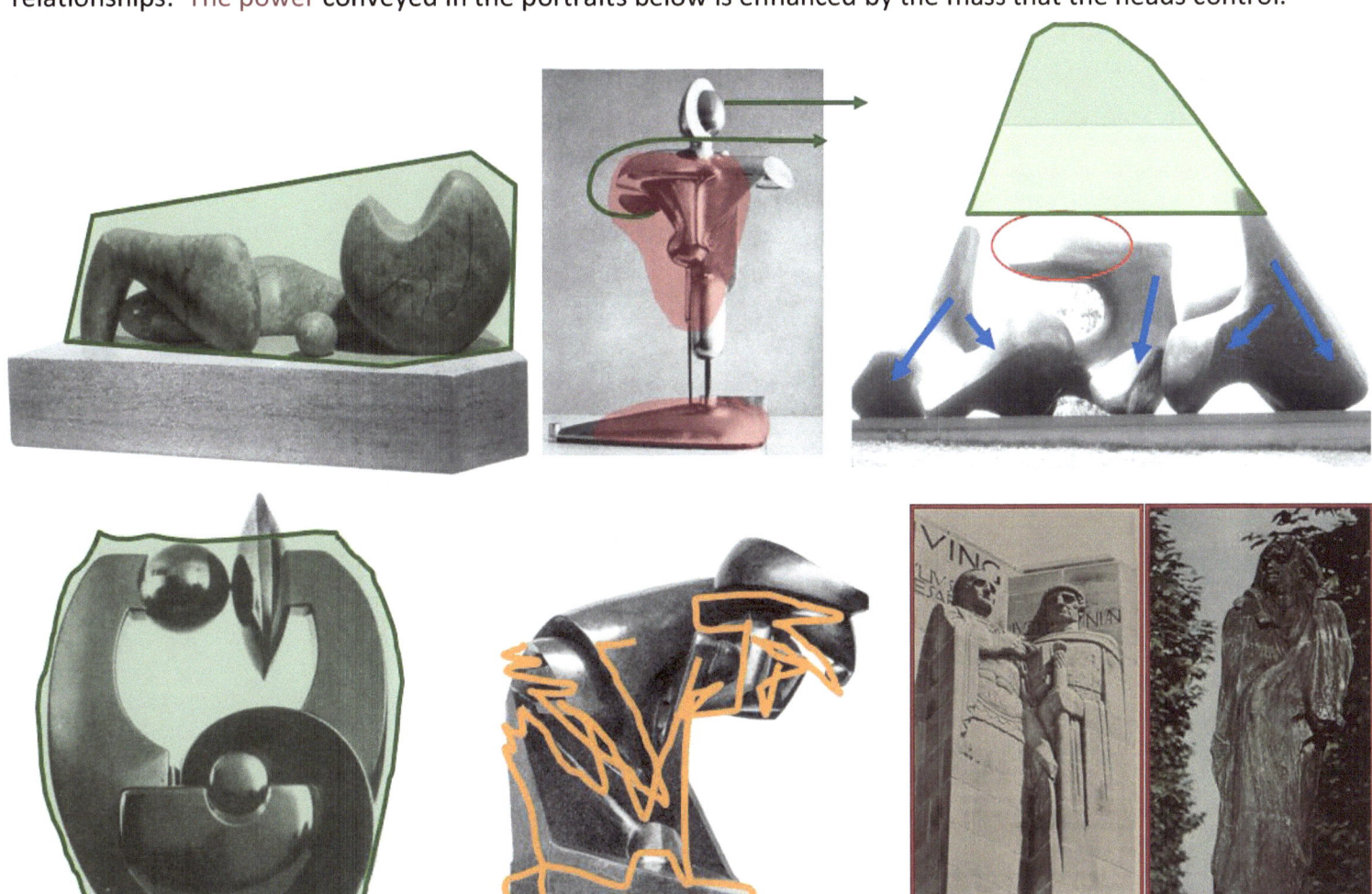

Volume is about the space controlled by the forms. Actual size of the space occupied by a form, or group of forms is volume. The material or the forms themselves may have little mass, like a screen, or exploded group of small objects in space. The control of territory beyond the forms is achieved through gaze, implication and psychological control from subject matter. A spider has little mass but volume of space around it is large. You do not want to come too close to a spiky, or slimy, threatening object. Like the illustration in **Line** the implied completion of form creates more volume in the Moore piece above. We have not gone into color but consider how color and texture can radically alter our perception of mass and volume. Dark objects appear much heavier. Glossy surface finish creates highlights that add new shapes lines and even illusion of new forms. The polished chrome on the warrior above makes it considerably lighter than it would appear in all dark, matt material.

Design Elements Organization Principles Technique Concept

Line Shape Form Contour Plane Mass Volume **Design Elements**
Proportion

Proportion is both a design element and an organizational principle. It describes the relationship of parts in terms of size, weight, volume, or visual intensity. Sizes of shapes and forms, lengths of lines, the curvature of arks and sweeps and the amount of groups of elements like color variegation,s textures and contours can all be observed as proportional relationships. If we think in terms of percentages we can review elements with a mathematic value. A great composition will reveal hidden formulas showing similarity or more complicated algorithms to the proportional values. The base below, compared to the objects on it, seems to be equal to or slightly greater in volume and has mass more than double. This stabilizes the piece. The sphere has such smaller proportion that it is emphasized by the difference. Note the proportions of negative space.

Famous mathematical phenomena like the golden section (right), and the Fibonacci sequence may be seen in great works, repeating of 123, or 369 sequences or prime number progression might be observed in a number of elements. Negative space can be a design element, just as strong as the positive.

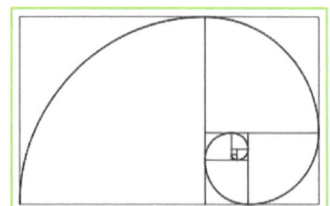

Concept | Technique | Style | Organization Principles | **Design Elements**

Organization Principles

Rhythm Balance Movement Emphasis
Order Space Unity Economy

How all those design elements become compositions

Now that you have a grasp of the design elements we can look at how they are used. The terms chosen here are for observation of art. They are basic terms that pertain to design composition and allow us to get a good perspective on how elements have been organized into a composition. Again, there are more terms and many variations but these are a great start. Each of these can be cross referenced with each of the design elements for assessment. i.e.: *What is the rhythm of the lines, the balance of the lines, the movement, emphasis etc.* of the *lines?* Each principle should also be assessed on the whole composition, reviewing all elements together.

The first four **principles** deal with the **dynamics** of the overall work. These give a sense of motion to a sculptural composition and can be assessed in any object:

Rhythm Balance Movement Emphasis

The others **have** more to do with the **artist's conscious decisions** toward a composition. They are the result of a great deal of **editing** which moves the work to be "just right":

Order Space Unity Economy

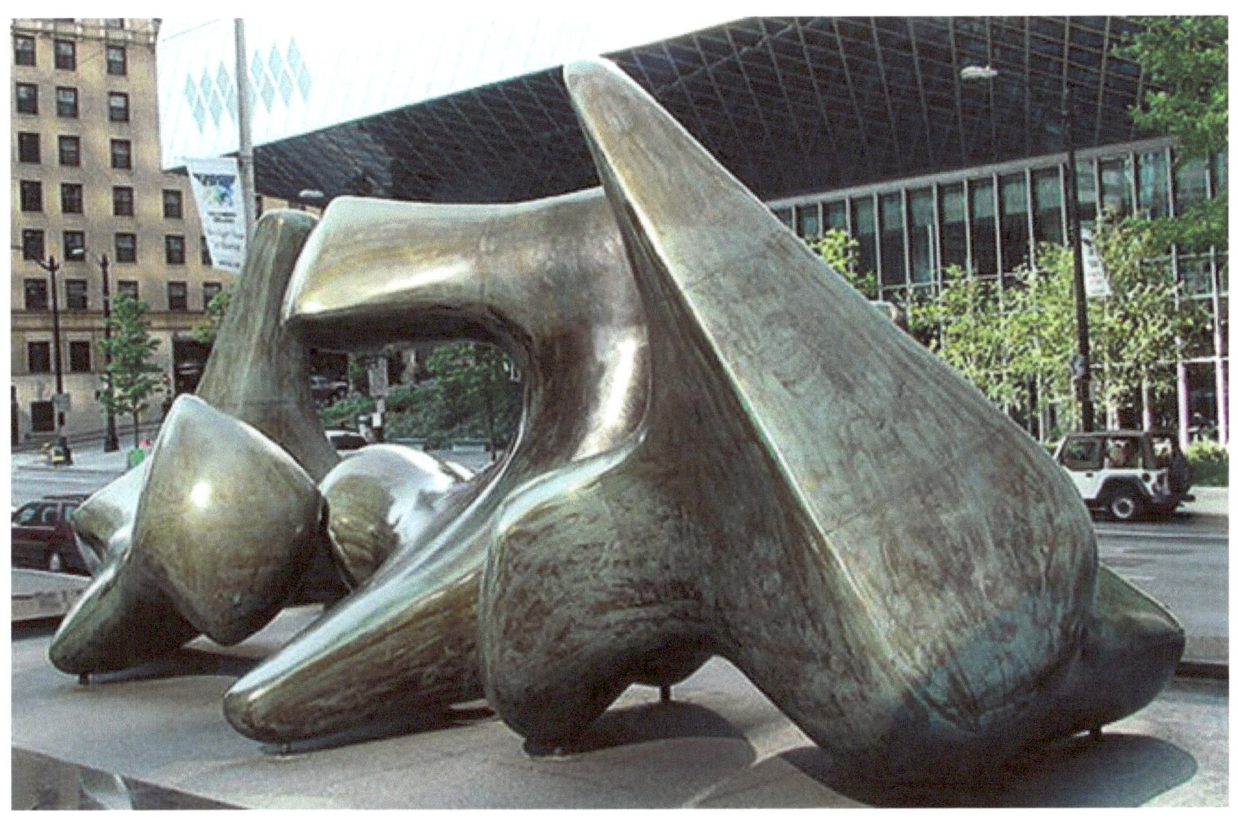

Organization Principles

Rhythm Balance Movement Emphasis
Order Space Unity Economy

Elements that repeat at intervals set up a rhythmic pattern. Similar spaces between forms, similar shapes on the surface, proportions that change in a noticeable increment all will convey rhythm.

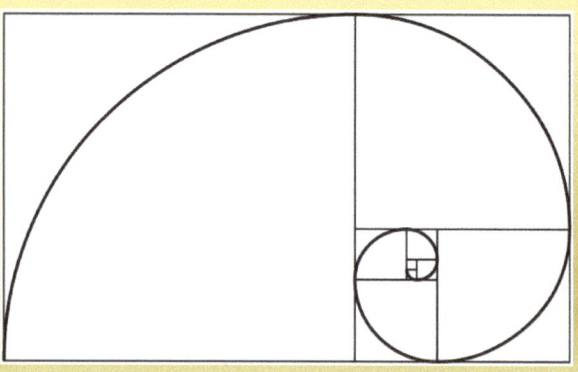

In the golden section spiral the arc is the same in each square, it shifts 90 degrees in each reduction in size, and the reductions are proportional to each other. Three identical rhythms achieved in different elements.

When the rhythm of one element matches another then a greater compositional order is achieved. Syncopated rhythm may be used to create a point of emphasis. Consider different rhythms used in one of the pieces pictured. As your eye jumps from element to element what similarities do you see? You can almost count off a visual down beat on many fine compositions.

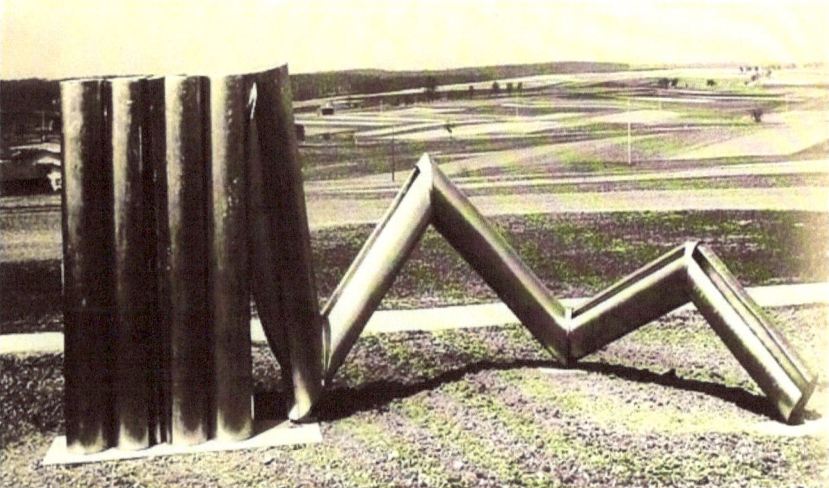

Repeating geometric forms are strong rhythm. The position change here creates greater dynamics and allows us to see new form variation in the slots (new levels of complexity).

Organic forms can seemingly mask rhythms. But highly rhythmic work is much more sophisticated. Note the form and shape repetitions in components here, and matching negative spaces. Yes it's an abstract horse, but also a fine rhythmic composition of forms and space.

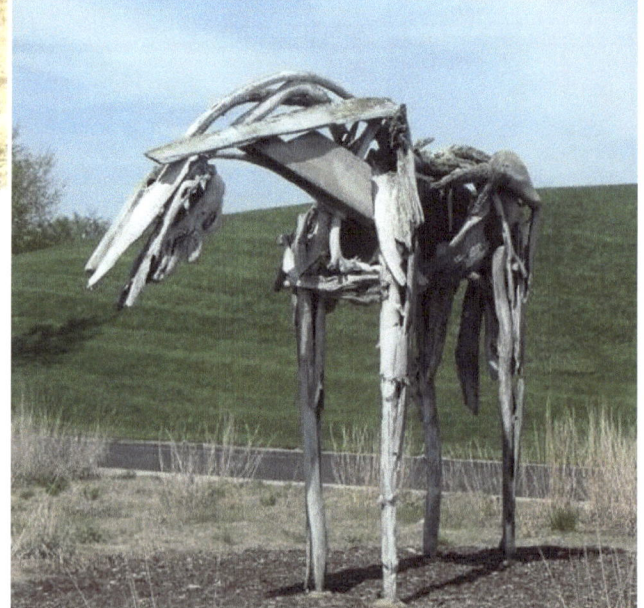

Concept | Technique | Style | **Organization Principles** | Design Elements

Organization Principles

Rhythm **Balance** Movement Emphasis
Order Space Unity Economy

The apparent stability of a form against gravity produces balance, but so does the distribution of visual weight.

This can be achieved with mass, volume, proportion, but can also be achieved with other aspects (we ascribe them subconsciously). A dark, busy, or brightly colored area or thick texture will appear visually heavier than a smooth plain or light one. Asymmetrical balance is achieved when weight is ascribed by different elements in the same proportions. What tips the scale of balance among the elements? Symmetry gets boring and extreme asymmetry can be disturbing. Typically balance in a fine composition is achieved among groups of elements rather than in one. A group of lines or shapes may be balanced by an adjoining mass that has equal impact. Bonsai trees are masterfully balanced via asymmetrical element use. We think of Mass and volume immediately (will it fall over) but what about the lines? Contours? Is there a relationship that tips the scales against another element? Great artworks seem to have imbalance at some levels but then on more careful viewing other things stabilize the composition, forcing us between ease and tension.

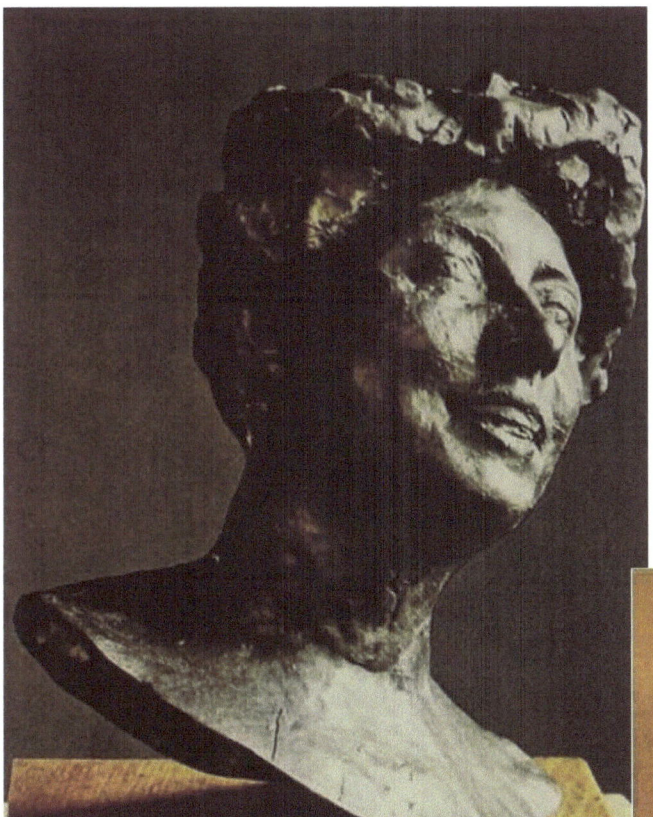

The physical poise, though precarious, is stabilized by the mass of textured hair and face opposite the broad smooth expanse of chest with a tranquil bottom line. The line, distance and attitude of the gaze also add psychological stability to the upper portion of the piece, enhancing the balance.

We don't notice the base immediately. The tree form dominates, yet the mirrored distribution of mass beneath, and the proportions of materials reach a fine asymmetrical balance.

Organization Principles

Rhythm Balance **Movement** Emphasis
Order Space Unity Economy

There are two types of Movement in a work:

1. **Static** (non-moving) to **Dynamic** (lively, moving, changing) Does a stationary object have a sense of motion? Escape from planted mass towards motion happens with change in form. When we can read the path of erosion or material alteration we get a sense of motion. Gradually changing surface appears to be moving. Surface development can result in highlights that "speed up" a form, indicating motion. An accelerated curve in shape or form will seem "fast." Reflective surfaces with directed highlights also add to a sense of speed.

2. **Aesthetic Distance-** (how we interact with the piece). Does it draw us in or push us back? Tension is also included in this concept. If an object appears to be spring loaded or unstable it seems dangerous to us, repelling us. Some elements draw our attention in a direction, or seem to control a space they do not really occupy. Obstructions to a path stop our visual progress, sharp and pointy edges tell us to keep back.

Moving the viewer with form: Where do the lines take you? Does the little journey with your eyes continue? Angles point and direct toward action, overhangs appear to defy gravity. Great sculpture will push you to go around it and see the next view, and continue to make you want to go around. Form Placements may have proportional intervals that indicate more forms or areas to look. The resting points for the eye are also important. Something akin to motion sickness happens when there is no rest area, unless the whole composition has such balance as to provide this.

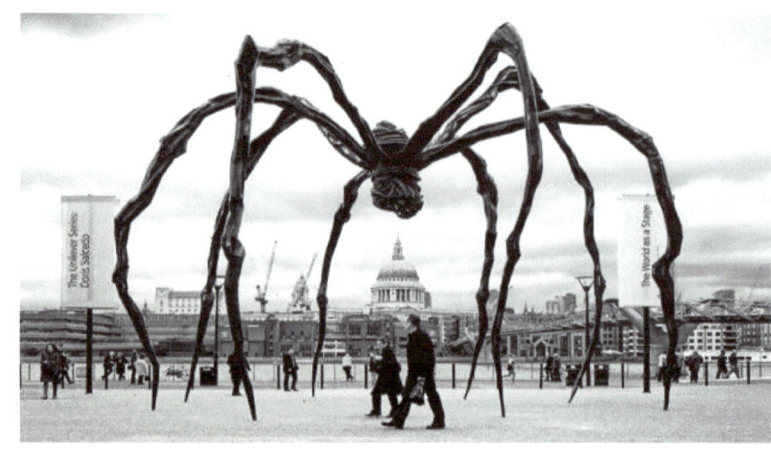

Organization Principles

Rhythm Balance Movement **Emphasis**
Order Space Unity Economy

EMPHASIS

Any element that stands out by itself produces emphasis. What is emphasized? How? And maybe even why? Lines and shapes can point to it, masses can pivot on it, contour can be interrupted by it, and proportion can enhance it. Emphasis is a choice made for a reason in good work. Conversely an error in craftsmanship can create unwanted emphasis in bad work.

The sphere in the Moore composition is emphasized by its smaller size, pure form, strategic placement at the intersection of theoretical planes, and indeed ties the rest of the composition together like a fastening button.

A point that is eluded to or directed to, by other elements, is one of emphasis.

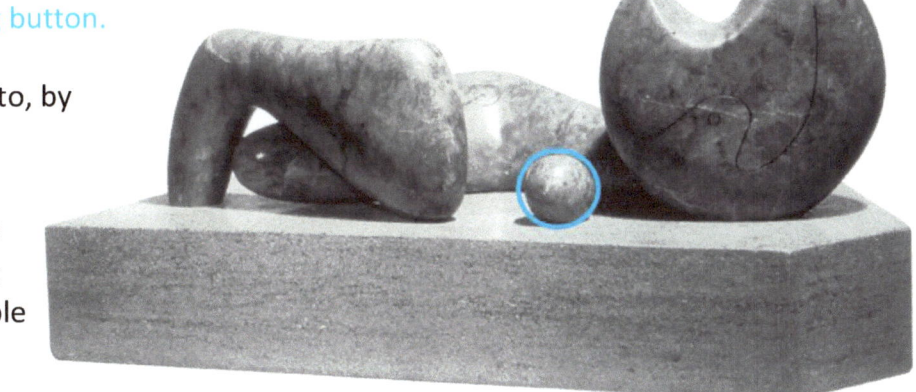

Order: Look for the way elements are arranged to create overall impact. What organizes this work? Are there recognizable proportions, or reduction of the use of elements that create a specific order? Has it been used throughout?

Some forms of order:

Classical or Formal order- Having mathematical regularity, stability and clear articulation

Biomorphic or Organic order -Having a structure like the forms in nature and living organisms

Asymmetric, Intellectual, Concentration, Hierarchic order - Each of these is a way to organize a composition. Various elements may have differing order. Some order is bold, precise and up front, other types are subliminal, less obvious. Again consider the order of individual elements and then the total composition to find its secrets.

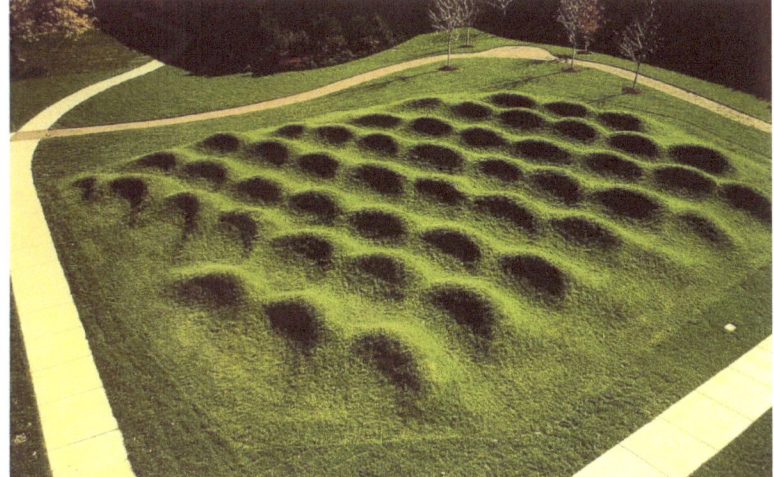
Formal order with biomorphic material

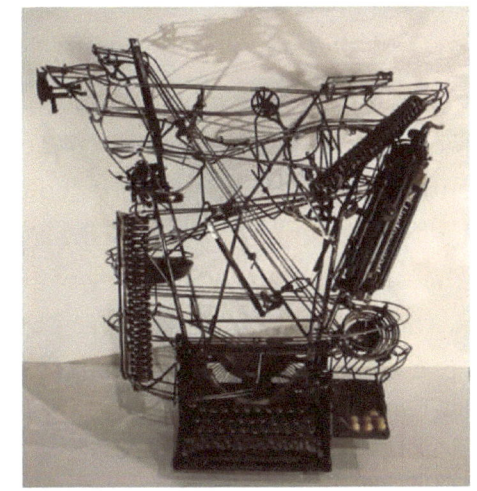
Organic order with machine material

Organization Principles - the editing group

Rhythm Balance Movement Emphasis
Order **Space** **Unity** **Economy**

Space: The use of space is a little more obvious than some principles. Positive and negative both need to be assessed as well as the psychological space that is controlled or seemingly occupied by the work, due to elements directing you or prohibiting you from going certain places. An object can control an area larger than it physically occupies, or can create barriers.

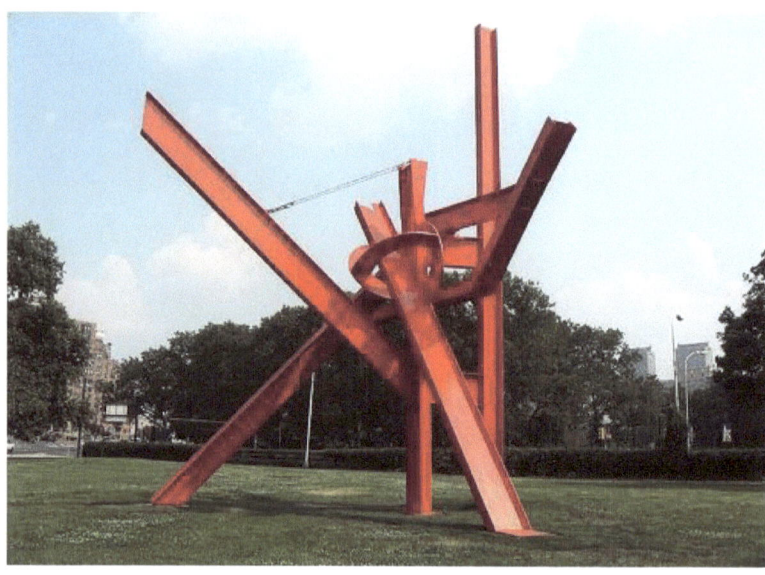

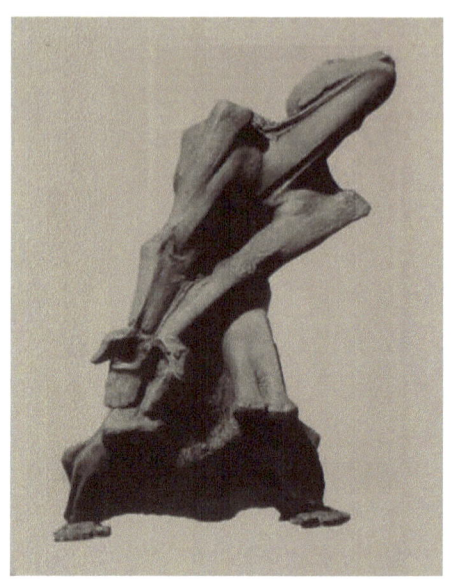

The figure of Cain stretches agonizingly toward heaven and points emphatically at the earth setting up a composition that references two spaces not occupied.

Unity: This is harder to do than one might think. All the little variations that spark interest and motion can have unity of composition. The size and length of lines, the contour groupings, a strong artist adjusts and adjusts until there is unity within design elements and between them. All viewing angles must be considered for great unity. Shapes, Forms and Contours in unity create a specific style. The shadow line spacing and form unity created on Cain above is very strong. The choice of almost all I-beam unifies the composition above. Poor technique can trash the unity when one area has a different level of execution than another. You see this with surface development and proportion on many works.

Economy: Reduction of design to its fewest elements for elegant simplicity (like the oriental masters). Indeed less is more! Often what is left out will speak much more confidently than too much inclusion. Editing down to the most significant elements is hard. Like poetry, can it be said with less? Look at the economy of elements in a piece of work. The best have fewer and yet are not boring but dynamic. A common mistake is adding extra ways of emphasis which then overpower balance or push movement into one direction only.

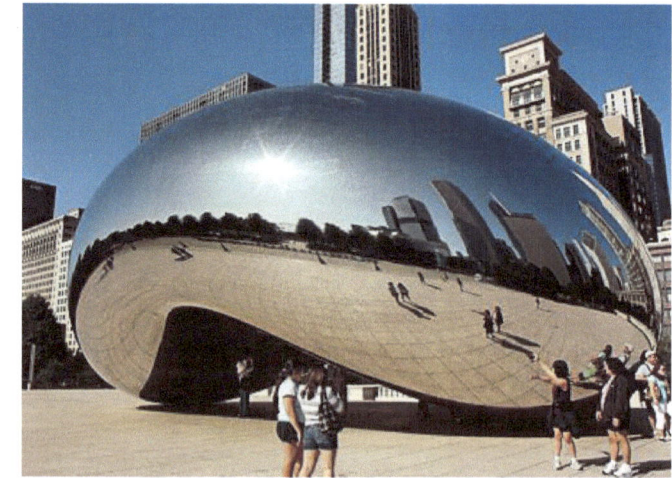

Concept | Technique | Style | Organization Principles | Design Elements

Organization Principles

Assessment Methods
Take a work of art and do two efforts:

1. Take a single design element.
Review each organization principle
of that element alone, then pick
another one and do the same.

2. Pick some random pairs
(one from each list) and review this aspect of the work

Line — Rhythm
Shape — Balance
Form — Movement
Contour — Emphasis
Plane — Order
Mass — Space
Volume — Unity
Proportion — Economy

Design Elements | Organization Principles | Technique | Concept

Style Shorthand for Art Classification

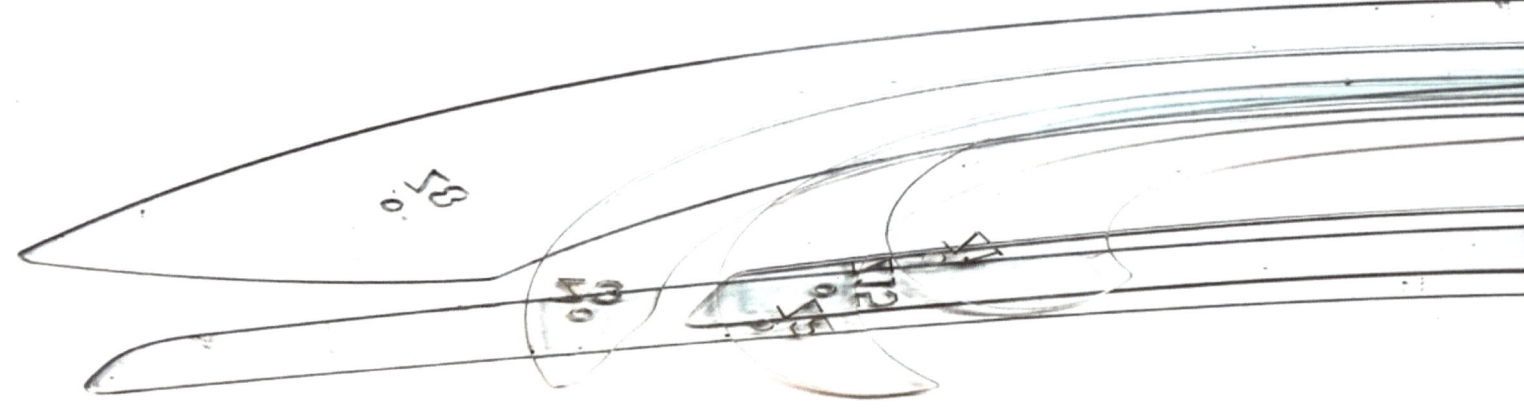

A formula for using design elements will produce a style.

These are evident through history and in different types of art. For expediency in this book we will lump terms like genres, forms, types, and even movements into the term "a style." Cubism is an easy example. Forms and contours are simplified into geometric sections and compositions created from the multiple harder edged forms showing sides of objects not normally seen in the same view. Here are two style s created at the turn of the 20th century, both still used today. One geometric the other organic in nature but both are very carefully designed graphically, producing a formulaic approach to lines, shapes and proportions that you will notice in many works.

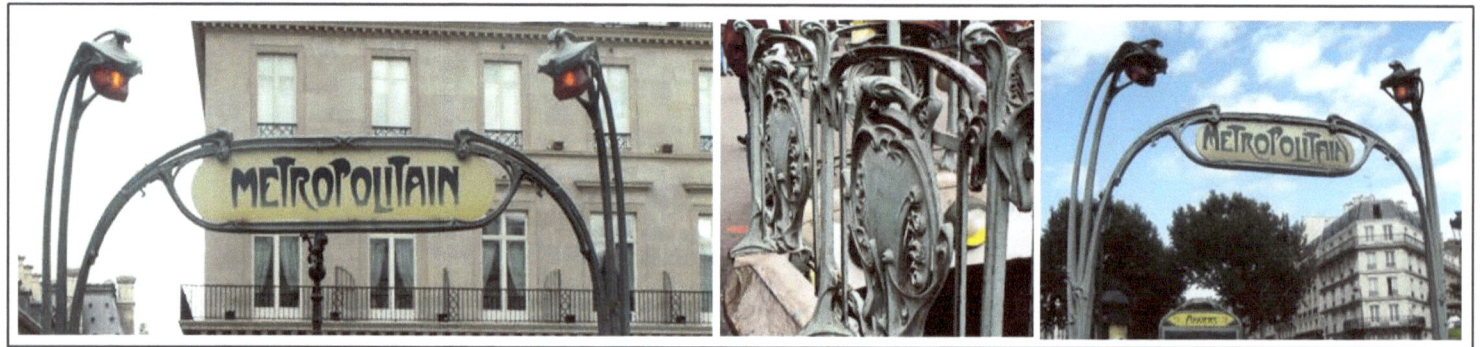

Art Nuevo- details, Paris Metro- Long sinuous organic plant like shapes are the hallmark of this style

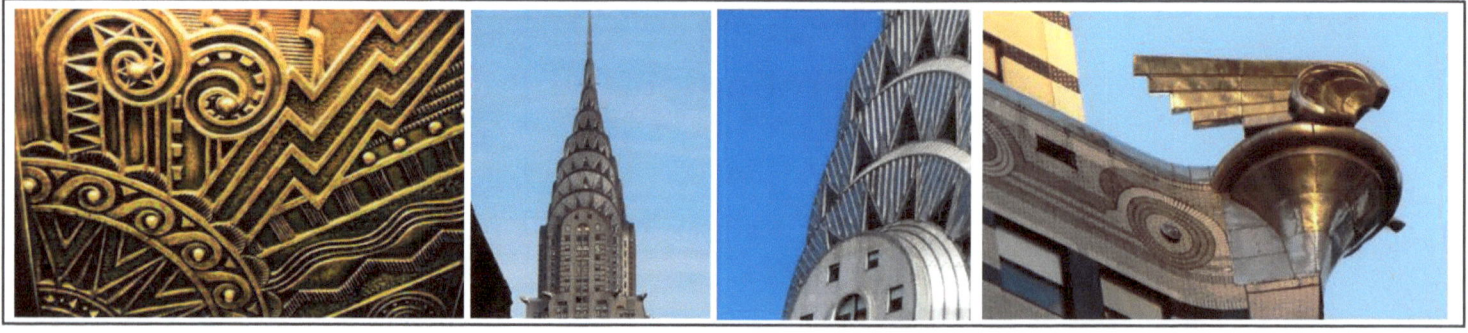

Art Deco- mostly geometrically derived shapes and forms with simplified contours separate this from Nuevo

There are three origins of style:
1. Cultural/Historic 2. Art Movements 3. Individual Styles

Style

1st Origin - Cultural/ Historic Styles: *A grouping of art works that have visual similarities, and like fashion, from a time period or culture*

These evolve over time, region and groups of people but their labels get associated with specific looks. So historic periods; Paleolithic, Greek, Roman, Byzantine, Pre-Columbian, Ming Dynasty, Renaissance, Baroque, may overlap with regions and cultures and peoples (Italian, French, Aztec, African), or religious or cultural groups **(see chart).** We will leave the dates and details to historians; we are interested in the way the art looks.

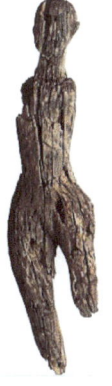
Primitive

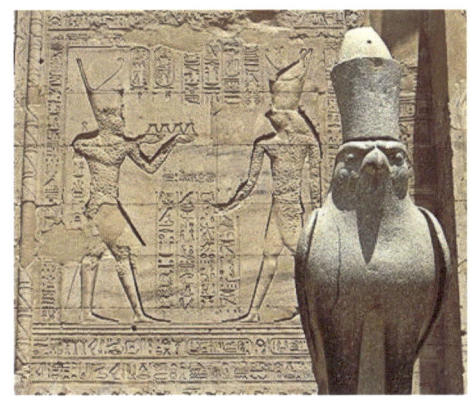
Egyptian

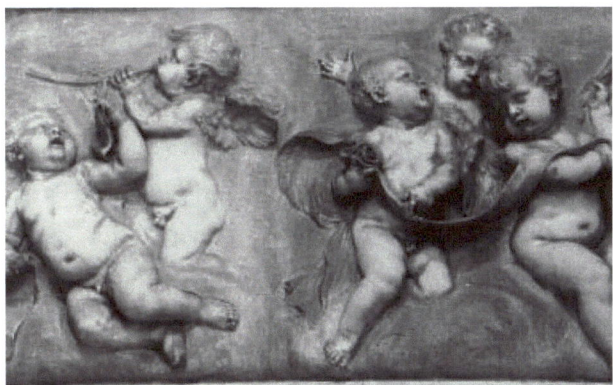
Baroque

In the chronology of art styles the dates overlap and most history timelines are based on western art development. These often do not include non–western cultures. Art not utilizing western principles is typically called "primitive" regardless of the point in time or place produced (tribal in Africa and American Indian, Inuit, south American, Asian Island). The dynasties of China produced many styles over the ancient to pre-modern eras, art from the peoples in the new world- Inca, Aztec, Mayan, are termed "Pre-Columbian." The Islamic, Buddhist and Hindu religious movements span ancient to current timelines and are more identified by their subjects and religious view. Communication in the modern age has allowed styles to move quickly across geographic boundaries. Now the place or culture may not be the influence of the style. And many Movements happen simultaneously.

Style History timeline

PREHISTORIC up to 3000BC (west) before recorded history

ANCIENT ART 12000 BC to AD 313 In the west
Far Eastern, Chinese dynasties, Japanese,
Minoan, Etruscan, Persian, various Mesopotamian cultures
Mid Eastern Egyptian, 10,000 BC to 300 BC

CLASSICAL Art- 1,000 BC to 313 AD (realism and composition formula)
Ancient Greek-1000BC c. 146 BC Ancient Roman 146 BC to 313 AD

BYZANTINE 313 AD- 1420 AD (Middle Ages Europe)
Loss of realism, shift to religious representation

PRE COLUMBIAN- up to 1492 - New World Americas- Mayan, Aztec

RENAISSANCE 1400 - 1800 AD
(Back to realism and enhanced composition)
Mannerism & Baroque 1600 - 1700 AD
Rococo 1700 - 1750 AD

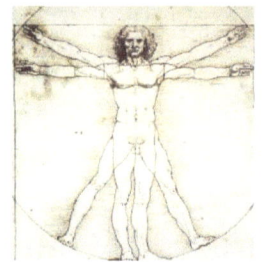
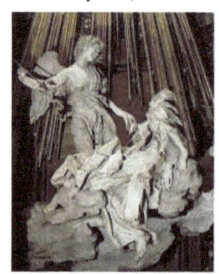

PRE-MODERN 1800 - 1880 AD
Neo-Classicism, Federal/Greek Revival, Georgian 1750/1880
Romanticism, Victorian 1800 – 1880
Realism 1830's - 1850's
Impressionism 1870's-1890's
(concept beyond realism-light study)

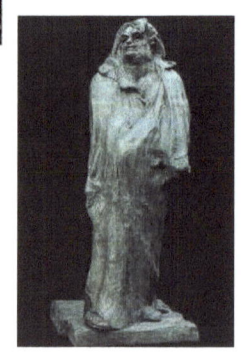

MODERNISM 1880 - 1945 AD
Post Impressionism, Art Nuevo 1880-1900
Expressionism & Fauvism Art Deco 1900-1920
Cubism 1907-1914
Dada 1916-1922, Bauhaus 1920's-1940's
Harlem Renaissance 1920's-1940's
Surrealism 1920's-1940's International Style 1920's-1940's

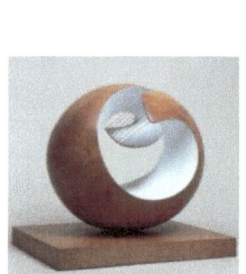

MODERN & POST-MODERN 1945 - Present
Abstract Expressionism 1945-1960
Op Art, Pop Art, Minimal Art 1960's, New Realism 1970s-1980s
Conceptual Art 1970s-1980's, Performance Art 1970's-present
Earthworks 70's to present
Neo-Expressionism 1980's-1990's Computer Art 1980's-1990's
Post-Modern Classicism 1980's-1990's
Victorian Revival 1980's-1990's
Digital Art- 1990's –present

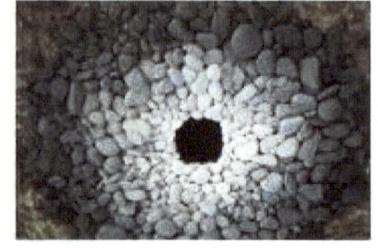

| Concept | Technique | Style | Organization Principles | Design Elements |

Style

2nd Origin of Art Movements

As we get closer to today artistic "movements" clump styles by ways of executing - **Primitives, Impressionists, Expressionists, Cubist, Surrealists, Op art, Pop art, Deconstruction, Precisionist** are all shorthand for styles have a certain design formula or way of working and continue to be used. **Impressionism** was the first break from **realism** and deals with light on object as opposed to realistic accuracy. This allowed many other movements of art (styles) to take root and be legitimized- **"Op Art"** about visual illusion and phenomena, **"Pop Art"** drawn from Commercial culture. Today we see imitations and reuse of styles form all time periods.

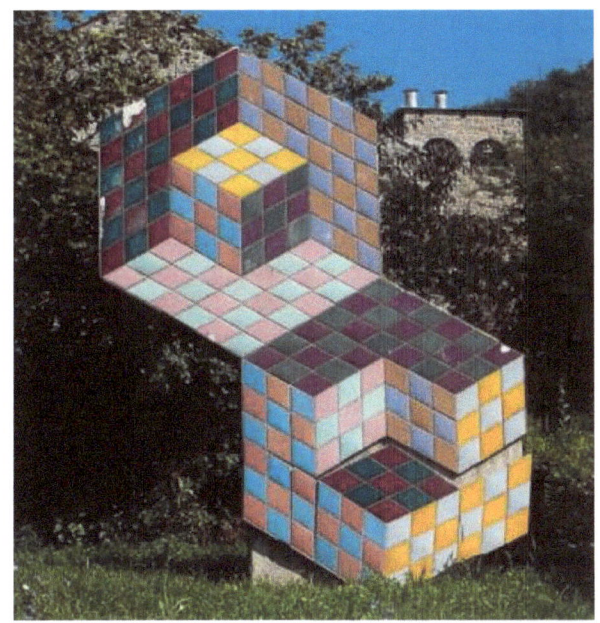

OP Art

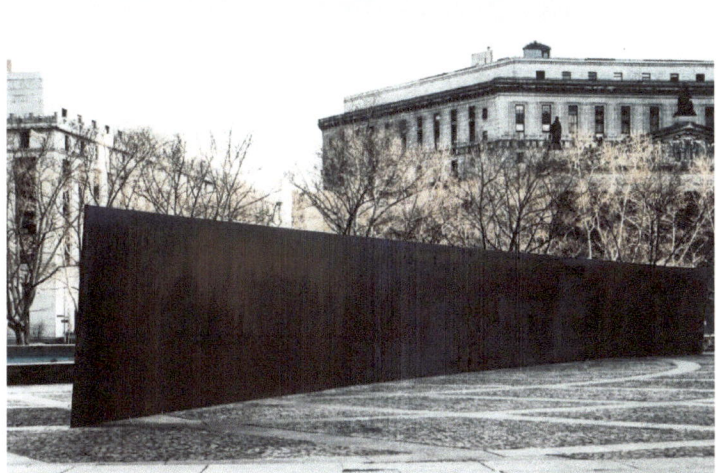

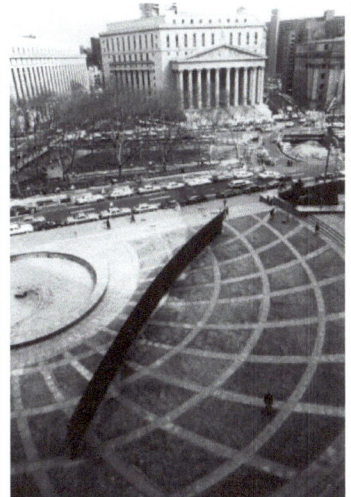

A monumental **minimalist work** by Richard Serra "Arc" caused a great stir for being removed by the property owners. The popularity of a movement may wax and wane.

Minimalism

Styles like Roy Lichtenstein's **Pop art** (with origins in close up views of printed comic book images from popular culture) become iconic for the artist and the age in which they worked.

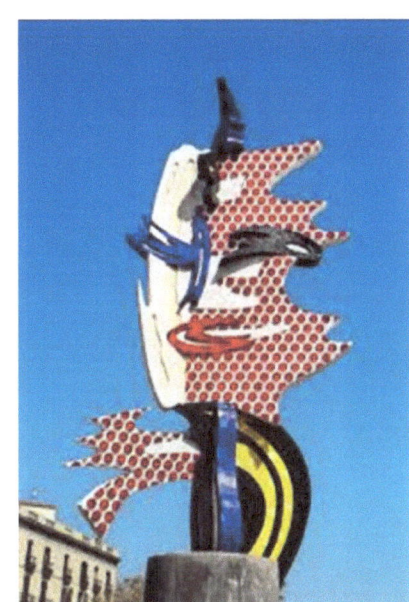

Pop Art

Style

3rd Origin of Style -Individual- The Stamp of an Artist

Some styles (and artists known for a style) have become standards, instantly recognizable: Mondrian's color, Calder's mobiles. "Rubenesque" is used to describe chubby women like those in Ruben's Renaissance paintings. PicassoHead.com has taken his typical painting elements and made a composition game.

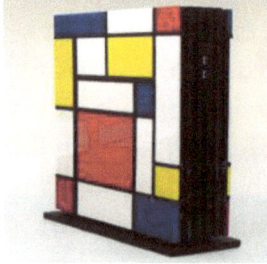 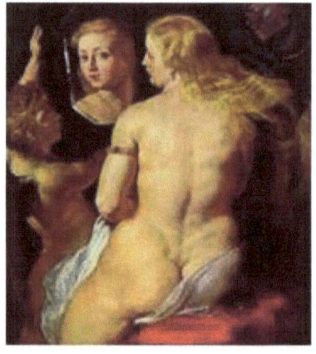

The style of a work is its own particular way of treating elements in a composition. A similar treatment of elements is recognizable when seen again in other works.

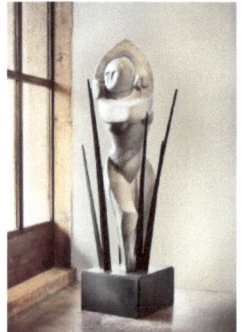 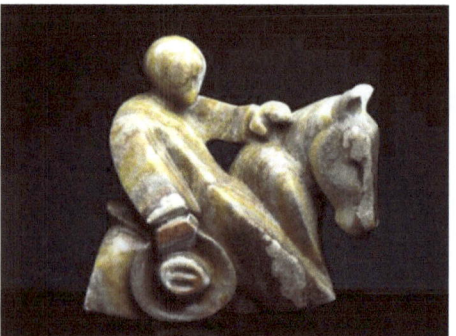 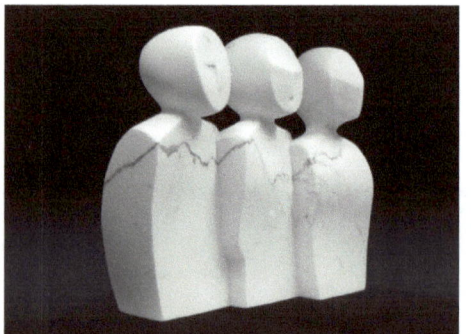 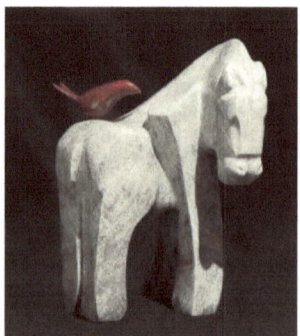

A style is derived from an underlying formula within design elements. These works by Mark Harris have similar contours, geometricized forms and lines, indicative of his style.

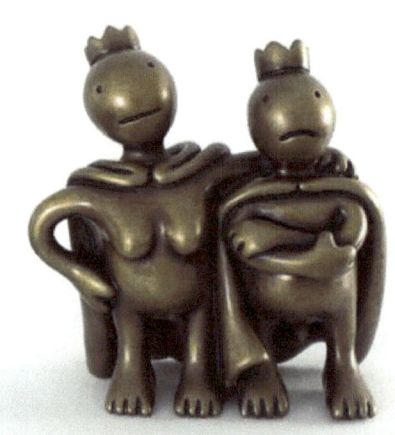 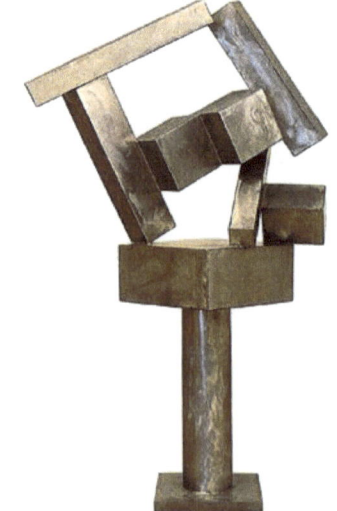 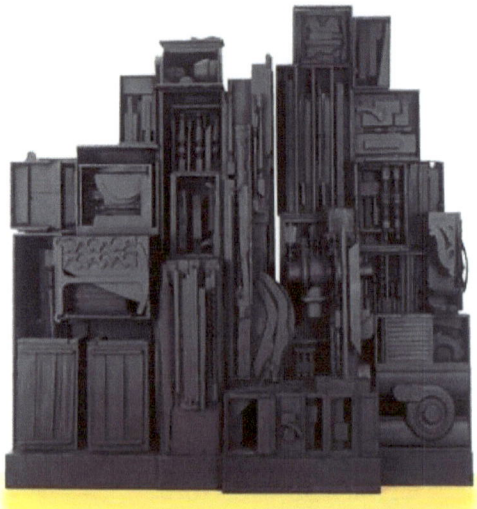

Cartoonish, simplified line and form are the trademark style of artist Tom Otterness. His sculptures depict many situations, often prompting thought well beyond just a humorous cartoon.

Geometric composition with crisp forms and lines, with very consistent texture and finish is the David Smith style.

Assemblage – the clumping of geometric forms into bookshelf reliefs and coating of everything in a solid color creates the style of Louise Nevelson.

| Concept | Technique | Style | Organization Principles | Design Elements |

Style

Crossing Time with Style & Styling

The style of **realism** attempts objective accuracy. It pervades most ages and impresses viewers by showing mastery of observation and technique for execution. In modern times it has been used to super amplify a topic or make a statement beyond showing technique. A work of **realism** may be a portrait of a person, thing or event, attempting a representation of it. But typically there are other elements used to push the **emotion** of the viewer further. There may be design elements used in a certain rhythm for emphasis; distortion, or execution techniques or material choices that add **drama** and push the representation toward a statement. It is boring to see a perfectly executed figure with an expressionless face on a motionless body, regardless of how accurate it may be. But strong representation of the human condition never goes out of style! A work of realism can enter into narrative, explaining a story with elements in the piece like emotion or symbolic objects or conditions.

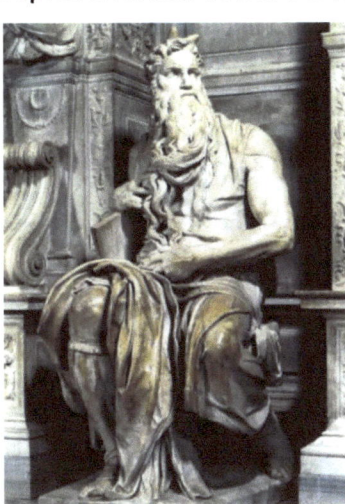

Realism: Roman

Renaissance

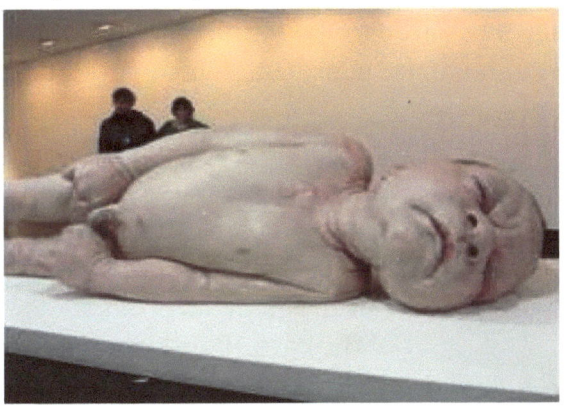

Modern

Styling— In industrial design "Stylists" make decisions on the design elements to achieve a unified formula. Items in a line of merchandise have similar lines, contours shapes and mass relationships. Artists employ the same type of thinking. "High Style" from the fashion world implies having been created by a contemporary designer (usually implying expensive). But this is not art. The concept is only excitement to sell product. Some artworks are mere stylistic exercises, mostly decorative and light on concept. These are considered more graphic design than true art. On the flip side much art has paid little attention to styling, leaving sloppy execution of line and poor thought to proportional composition. As you look at the composition of design elements in more art work you will begin to appreciate the interesting balance of styling, concept and technique.

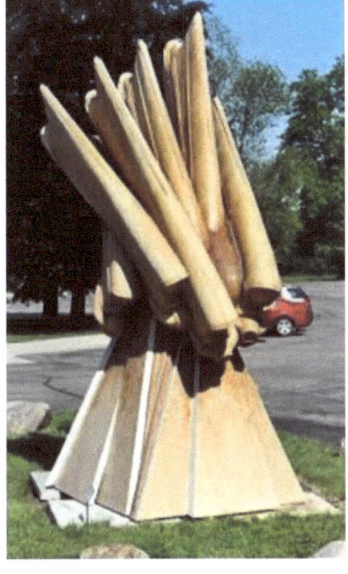

"57 Descending" at right utilizes color, line and shape from a famous **cubist** composition ("Nude Descending a Staircase" by Duchamp) and the equally famous forms and styling details of the 57 Chevy to create a new 3D composition.

Assessing style:
How are design elements used? Is there unity? Is the composition related to a known style? Is there repetition of technique? Is there an order or rhythm that creates a unique look?

Technique - How the Artist Executed the Work

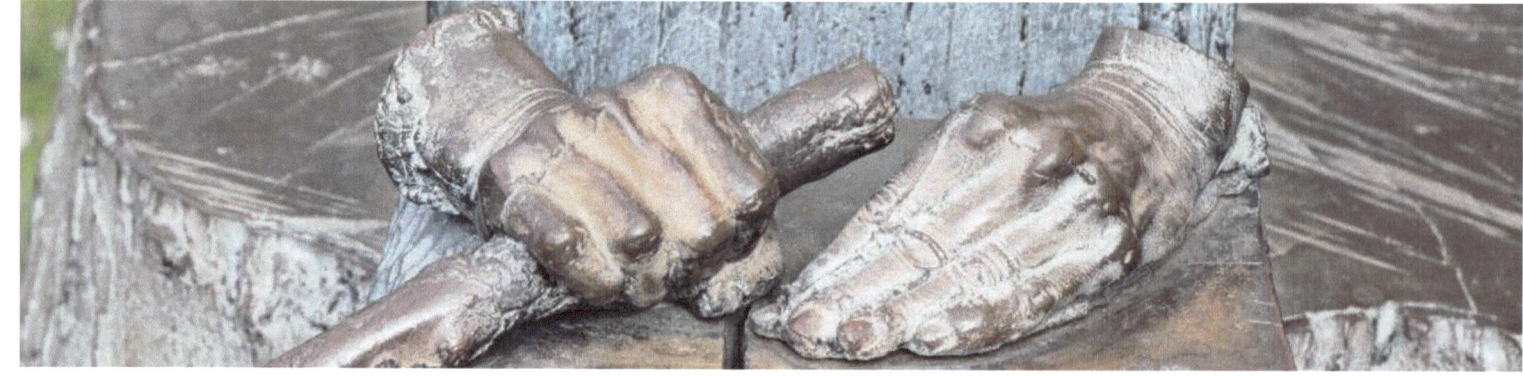

Method and Material:
The first aspect of technique is material, and how it was manipulated into a work of art. Carved stone, molded plastic, cast bronze, and welded steel come to mind. Some pieces are constructed; others are modeled, molded and cast. The term **Medium** is used in art for materials i.e., clay, cast metals, fabric, composites, organics, welded metal, paper machete, cement, stone and all. Every artist has her/his way of making art which constitutes technique applied to medium. The craftsmanship may be so refined that the touch of a human hand is not really noticeable. Conversely the modeling, hash marks, hammer blows, chisel gouges or weld spatter may be utilized for powerful emotional effect. When we look at technique we should see continuity. Obvious changes in execution technique should be on purpose, for emphasis, and not accidental.

Modeling:
Composing proportion of contour with the mass of material is the skill of modeling. On a modeled form we look for continuity in texture, tooling and contour development. Similar areas should be at the same level of execution. Emphasis happens when this is not the case. Poorly modeled areas stand out. Modeling produces a style. If representational, is it cartoonish? Accurate? Distorted? How so? The choices on proportion, line, and contour create the image. Inaccurate anatomy should not be oversight but serve the concept as purposeful abstraction. The rhythm of detail should be lyrical and accents should be powerful enough to create impact.

Molding and casting:
Since most modeling materials are not permanent, a mold is taken and a casting is made. Molds can produce lines and material changes that enhance or detract from the work. Casting materials can vary in quality, color and reflectivity; if these conditions are present on finished work they should be intentional.

Concept | Technique | Style | Organization Principles | Design Elements

Technique

Carving is purely subtractive method, but must achieve the appearance of modeled surface in the end. When techniques vary they create accents. Etching and various micro carving techniques may be used to enhance surfaces and obscure or accent joints or transitions.

Transforming- Hammering, bending, stretching, molding, CNC printing, burning, all may have been employed to create form. An artist will hone a technique to get just the right finish results within the process of making. The motion of fabrication can be a powerful element in composition merging the activity of the maker as modeler, bender, hammerer, grinder, to the concept of the piece.

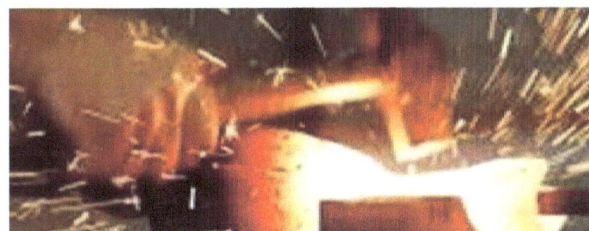

Joining- Welds, seams, bolts, stitches, various other assembly methods become lines and affect contour. The placement and spacing of joints should produce good lines and accents and not disrupt the piece. Materials joined should be of equal quality, otherwise unwanted accentuation may happen. Joinery is a major element in assembled works.

Finish- Working a material produces texture on the form. The color patina should relate to the material, modeling, and tooling techniques. Choosing to leave an area unfinished is a powerful statement in itself. All finished, all the time, everywhere, might as well be a manufactured object and caries less emotion than careful choice on finish levels. Scale adds to the complexity of these choices. Jewelry is made to be contemplated close up. Monumental sculpture may have a very different feel at close inspection of detail than when viewed at a distance.

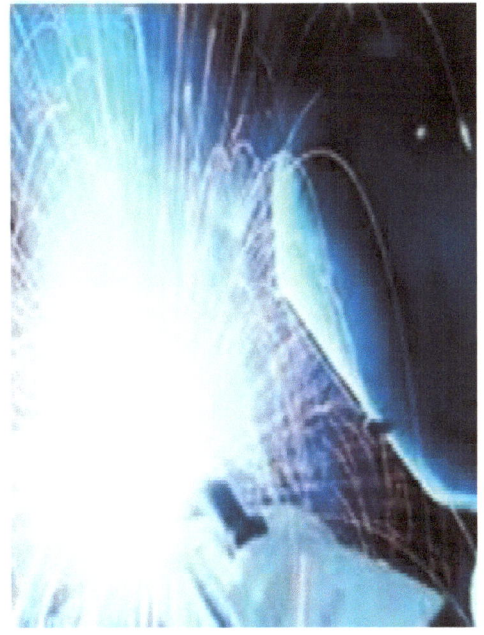

Assessing Technique:
- Is technique important to the form or concept?
- Does it help or hinder the work?
- Is execution consistent? Are modeled surfaces unified?
- Are fastenings well placed, sound and appropriate?

Technique *A good assessment practice: consider the art at various distances.*

- **At long distance** we see the total composition, major lines, mass, volume, and attitude that was designed.
- **At medium distance** we see the contours, style elements, major intersection techniques, material choices, accents and composition elements.
- **At close distance** we notice execution- texture, finishes, fasteners, color subtleties, and material quality.

If there are surprises between viewing distances they should be positive or intriguing ones, and not disappointments. The concept may be evident at all three viewing distances or may change as we get closer. Often a difference in elements at various distances *is the concept* or may add to a narrative.

Craftsmanship will be evident at all levels, first in design, then material choice, then execution technique. But *fine art* will combine these into a powerful concept that is fresh and original. Sometimes carefully piled rocks can say more than over labored modeling, joining and finishing.

Concept | Technique | Style | Organization Principles | Design Elements

Concept

Concept: *noun* 1. - a general notion or idea; conception.
2. - an idea of something formed by mentally combining all its characteristics or particulars; a construct.

What is this piece about? Is there an intent, and what elements have been used to express it? Each work has its own **concept.** Art can range from a simple representation to incredibly complex number of combined elements, or be reduced down to an absolutely minimal thing. In artwork the concept may include imagery, story, and subject matter, or it might be more about the materials it is made of and the way they were used and manipulated. A work's **concept** is what it is about, conveyed by the other major categories; **design elements, organization** and **technique.** All too often a maker has not considered the concept and has just made something, with confused aspects and elements.

Historic perspective on concept

The concept of art before modern times was mostly representational illustration, commemoration, decoration and entertainment. As modern tools to do these things developed, art began to have deeper concepts. Some people use the term "theme" for concept, meaning representation, psychodrama, statement, story line or narrative. (Theme is also used as a graphic term akin to style).

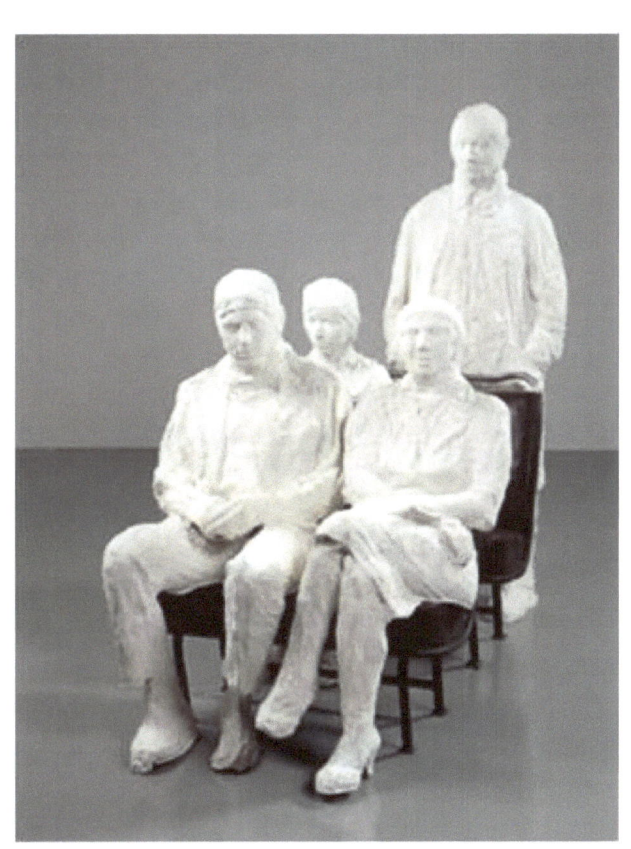

Underlying what has been graphically portrayed may be much deeper information about the work's origins, like the artist's relationship to the subject, or special techniques solely relevant to the work (a work about herds carved from multiple cattle horns for example). The modern movements, genres, types, and styles pushed new functions and ideas for art to wield. The 20th century created "Concept Art" which condenses a concept and strips away most graphic elements that revolve around beauty and design, to get to a raw idea. "Dada" (WWI) was anti art and "happenings" circa 1967 had no identifiable traditional design elements. Concept art may have no physical object at all!

Concept and Styles

The list of types of art is huge, confusing, overlapping, and growing all the time. We will deal with a few basic types to help you see the differences for the purpose of assessment. Certain concepts have been so strong that they become labels for types of art. Cubism, Minimalism, Reductionism, most all the "isms" are derived from a concept about designing the art work. This overlaps with a "**style.**" The section on **Style** will address many commonly defined types of work that are recognizable because of the graphic treatment of their **design elements.** Style in our system is about graphic look, where **concept** is about the idea. Some bodies of work deal with familiar subjects like the human forms above. This artist almost always makes the forms the same way, hence his recognizable **style**, and they are usually groups of human forms, made like bandages. His concept deals with human interaction creating subtle narrative. His style has a process driven lack of detail, emphasizing the forms and the emotion in body gesture. You read them as situations, not as beauty.

Concept

Three Major Types of Art – (The beginnings of CONCEPT classification)

Representational → Abstract → Non-objective

 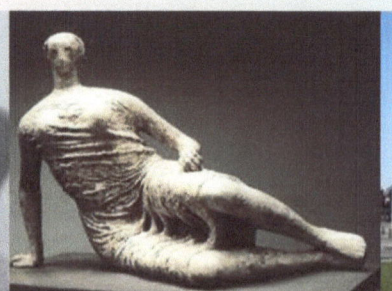 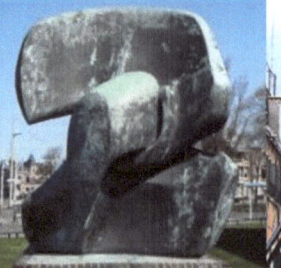 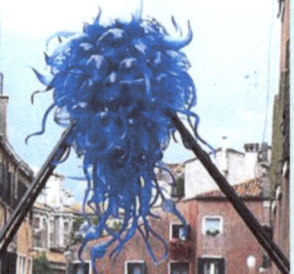

1. **Representational**- Literal rendering of a person, place, or thing- or realism. The focus is on reproducing the object with accuracy. This is easiest to analyze because we can compare to the actual objects we know.

2. **Abstract**- A literal subject may be distorted for effect, composition, emotion, or to a point of being barely recognizable. Elements may be presented or included purely for their own aesthetic effect and not represent anything else.

3. **Non-objective** - Designs taking virtually nothing from known objects. The composition may be purely graphic in construct or have an order of its own, organic or geometric in nature. Unfortunately some high forms of this type of work, like Jackson Pollack's (below), who did totally non-representational paintings, are known as abstract expressionism. (sigh)

A sliding scale continuum- upon which most traditional art objects can be located

Exact classification to one of these three definitions can be vague or dependant on knowledge of the subject. Most art objects locate easily on the line. Our tools for assessment are amazingly effective on all three types. Design Elements and Organization Principles can be the main discussion tools in abstracts in the middle of this continuum. But out on either end, in realism or totally

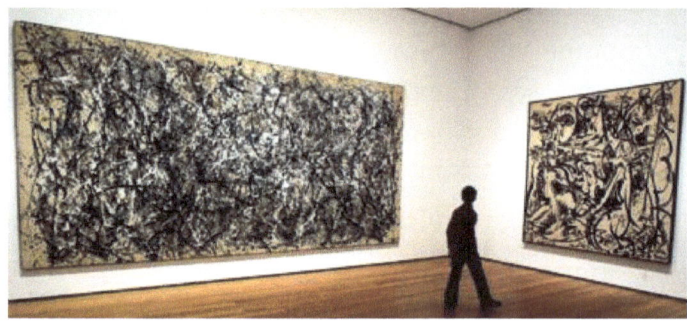

non-objective, we may be looking for psychological motivation beyond graphic design. WHY was it made, and what supports its impact? The concept might produce an emotion or mood to relax or entertain the viewer. Art can be for psychological and healing purposes, for social inquiry, subversion or anarchy, for propaganda, or commercialism. Has the art been created as a mere entertainment? Decoration? Or is there a statement? Historical references, symbols, events, other artworks, or imitative techniques may be employed toward a statement, concept, or narrative. The more you know about styles and art history the more you can see and separate out these elements.

The key to concept regardless of type, or style is: *"What does it say? How does it say it?"*

Concept

"Concept Art" A great deal of modern art falls into this category where the idea is far more important than beautiful design.

Traditional Craft

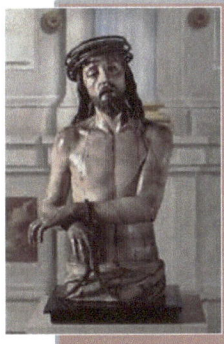 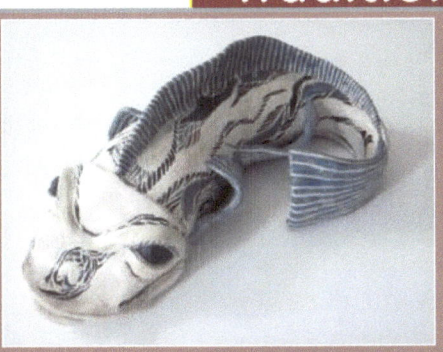 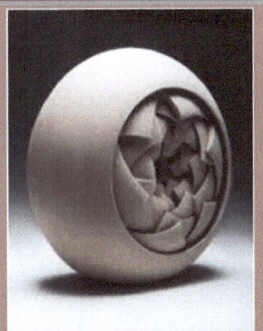

Realism, Representationalism, Form Composition, Styling, , and Decoration

Concept art moves away from traditional objects that have been designed to be permanent, created for beauty and displayed like museum pieces.

Object ↕ **Idea**

Concept artworks no longer depend on making an object. They may use manufactured items, or impermanent materials, and are presenting an idea that may not deal with beauty at all, negating our basic design elements. The debate over Fine Art vs. Crafts resides on this axis.

> **My sculpture is the space between these words and your eyes**

This piece by Robert Morris from about 1970 takes minimalism to a refined extreme. The art exists with no materials, in a specific space, for only seconds as each viewer looks at the words. Yet each viewer sees and interprets it. There is simple profound truth to this little piece and a "beauty" of fleeting austerity.

Concept

"Concept Art" - Not for Beauty, Style, or Longevity But a (recombined) idea

amplified
re-examined
recombined
shocking
twisting
simple
new
odd
wild
intense
inverted
passionate
paired down
circumspect
profound

A separate type of Art where idea is everything.

Often these works are attempting to drive an emotional or intellectual response from the viewer and not at all concerned with the visual design elements, style or execution techniques. These elements are often considered superfluous to the message being conveyed in these works. Many concept works are temporary, made of low or no cost materials and have no intent toward beauty and longevity. Subjects like death, decay, organic activity, growth, material manipulation, and mass production may be combined or created with any type of object or arrangement. What clearly portrays the idea? Strong pieces convey narrative.

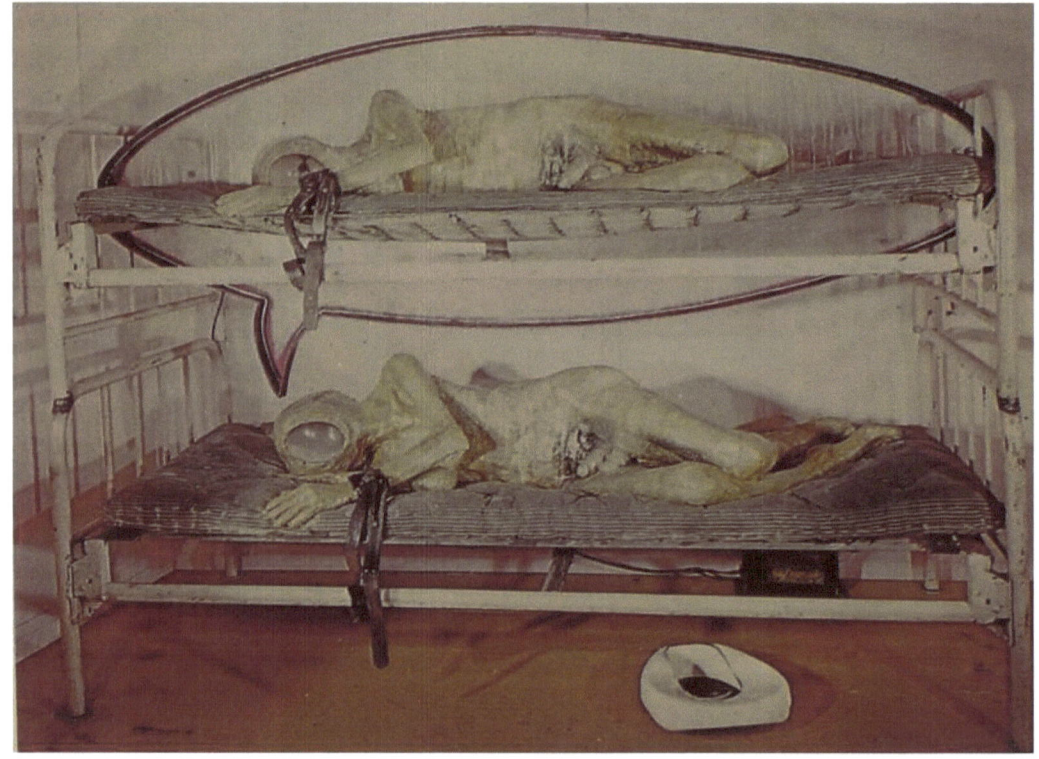

Assessment Keys:
Originality, profundity, depth of interesting perspective - Again, if you think you've Seen it before it probably is not all that original. If it shocks, is this worth an encounter? Many works fall short, are just mundane, trite, or simplistic without being elegant or mysterious. The best concept art is profound, simple, powerful, and manages to use interesting design elements.

Concept | Technique | Style | Organization Principles | Design Elements

Concept

Foundations: The crux of a concept can be created many ways. Here are a few:

1. **Subject Matter, statement** may be the **intellectual message**, **emotion** (joy, celebration, peace, serenity, fear, power) **symbolism**, **irony** (an important term in a strong concept - satire, paradox, sarcasm, dryness, mockery, causticness, insincerity, sardonicism, all opposites of sincerity, may be used.), **hierarchy** (reversing, exaggerating or pointing it out), **sentiment** (appealing to an emotion with an image or object known to tug at empathy, trigger absorption convey the human condition) and **humor**. (Wit, implication, double meaning, biting wit, may prompt us to think more deeply. Humor can be crude and infantile, however skilled use of design elements and careful restraint of exaggeration can produce a fun, humorous concept.)

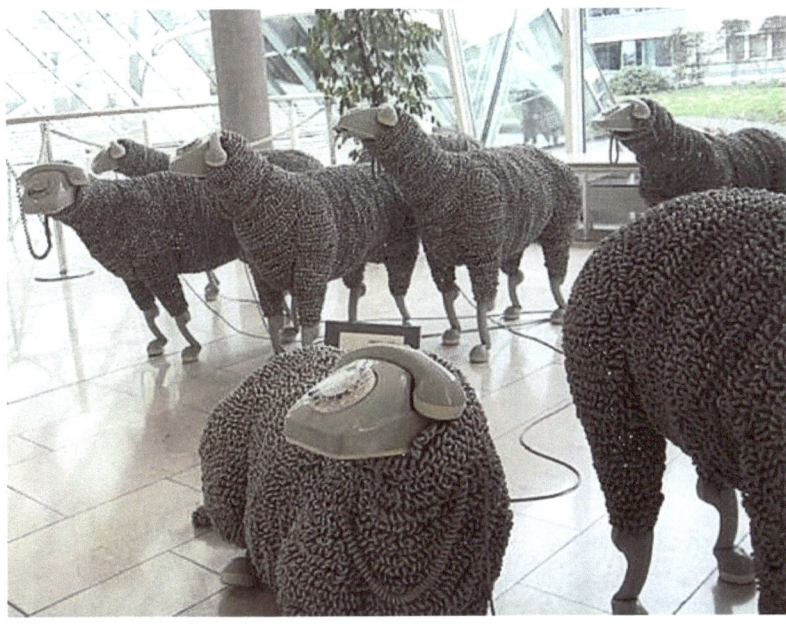

Illusion, allusion, or elusion

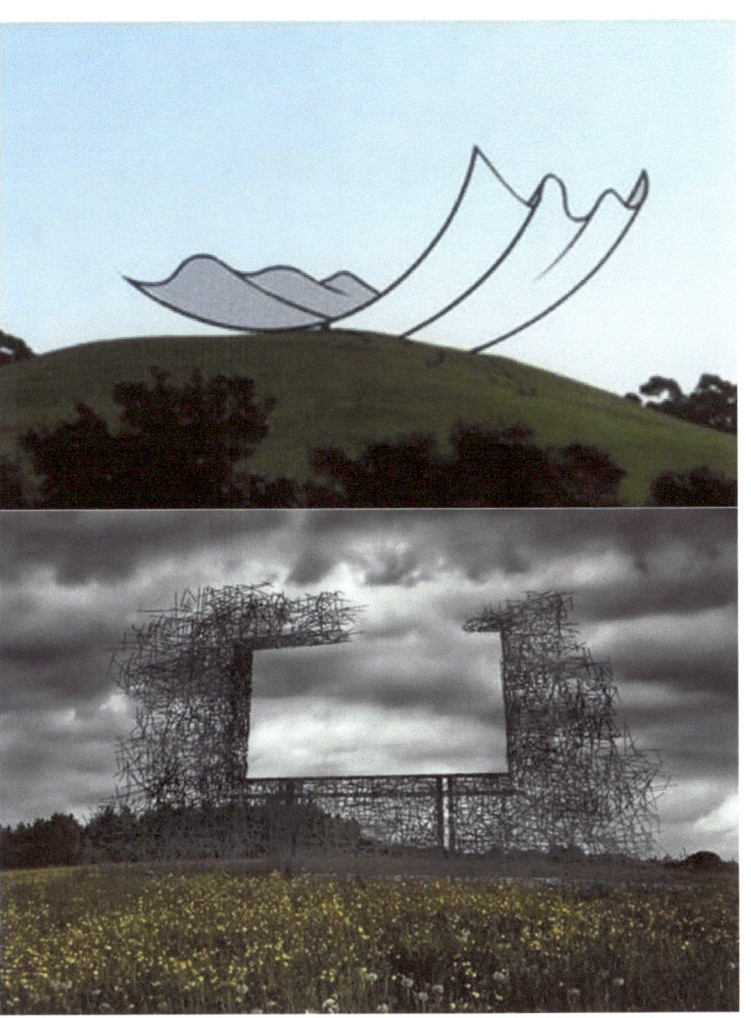

2. **Constructions, methods and materials** can become basis for concept: Imitation of other materials, odd scale, distortion or fastening techniques, swapping out one material for another, hard for soft, organic for architectural; using **kinetics-** actually animating or adding elements that move or change.

3. **Combinations, Fusion-** putting together things not typically associated with each other, and **distortion or** exaggeration to prompt a different perspective (most popular is scale).

4. **Psychological distance** and **Space control**— Some objects are scary, threatening or disgusting, pushing us away, others are inviting, friendly, alluring, familiar, drawing us closer. Both subject matter and design elements can have these effects. The apparent gaze, reach or gesture of a form can also control more space than it occupies.

5. **Imitation: of a subject, motion, or gesture**— Abstraction of gesture or motion can elicit beauty with sparse subject matter. Most work imitates something. The human face and form are most common as they arouse us quickly. Next are creatures and items of nature. We have been representing these for millions of years. New twists to objects shrewdly implore us to recognize them in new settings or materials.

Concept

Assessment tools—a quadrant assessment on two elements: Truth and Beauty

The extremes of these two aspects create a two axis, sliding scale assessment grid, on which all works can be located.

Quadrant 1: (Traditional) Ancient Art was aspiring to beauty and profound message.
Quadrant 2: Purely graphic design falls here. Many Artisans spend all their time crafting here on work that has nothing to say. Technique-driven work falls here if it is well crafted.

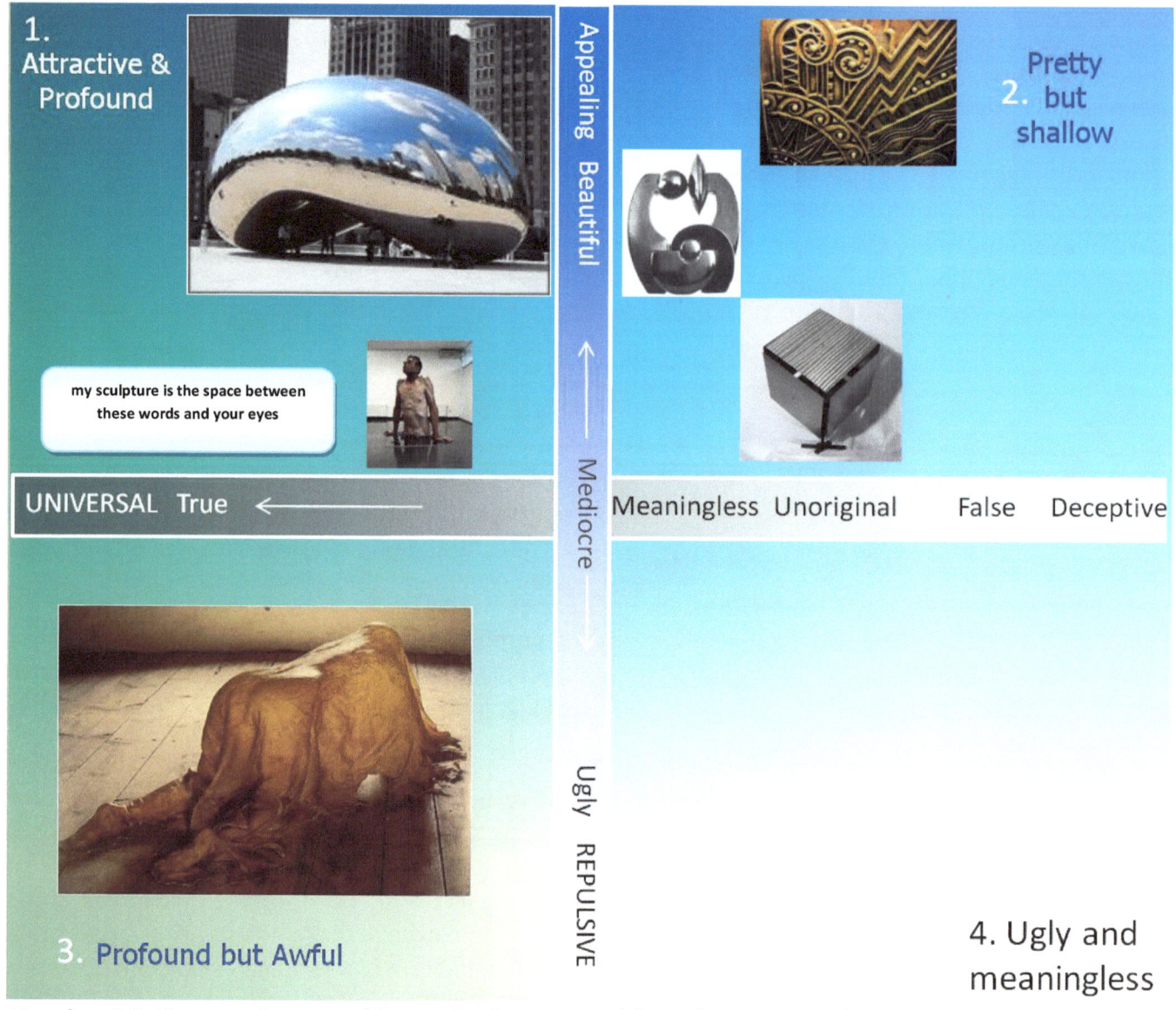

Quadrant 3: Concept Art says this area is also acceptable and important, (truth can be ugly but profound) and can even dismiss works done for quadrant 2 as shallow, vain, or purely decorative or commercial. Some works in quadrant 3 may be ugly at first but examination reveals design elements to be carefully constructed and having unity (a certain kind of beauty). If the message is both true and strong (i.e. profound) then there is value. Without beauty, a negative truth may be awful and hard to accept or deal with, but still true.

Quadrant 4: Merely ugly and disgusting with no lesson, message, or mystery has no value. Many hacks take pride in their rejection but have said nothing and produced nothing elegant, relegating them here.

Concept

Reviewing Opposites

Many extremes can be put on a quadrant grid for assessment. Think about what aspects are important to a work, consider the list below. If a work is hard to place on the graph it has certain mysteries. Great art will be hard to define!

Fascinating, Arousing

Tangible, solid, permanent object ← Less permanent materials | Ethereal, Illusive, Intangible → **Idea without form**

Boring, Soporific (will induce sleep)

Opposites:
Sentimental vs. Intellectual
Empathy vs. Repulsion
Juxtaposition vs. Unity
Parts vs. Whole
Stark vs. Rich
Clarity vs. Obscurity
Melodramatic vs. Subtle
Motion vs. Rest
Simple vs. Complex
Organized Vs. Random
Celebratory vs. Condemning
Peaceful vs. Violent
Serene vs. Anxious
Obvious vs. Mysterious

Concept

Narrative – A story of a Subject, Material, or Feeling

In much realism and traditional representational art there is a story told by the composition and all the little details in the work. As we have moved into modern times the idea of a Narrative has moved beyond realistic representation but still seeks to tell a tale of some sort. There are thousands of ways to do this, and powerful stories. Slices of human stories, combinations of ideas about materials, and strains of thought about psychological situations, may be involved in the narrative of a piece. Sometimes the things driving an artist to make what they create, and the multiple narratives that are involved with their works, will not be obvious in just one piece. This topic is huge but I will show one artist's approach to help you grasp it.

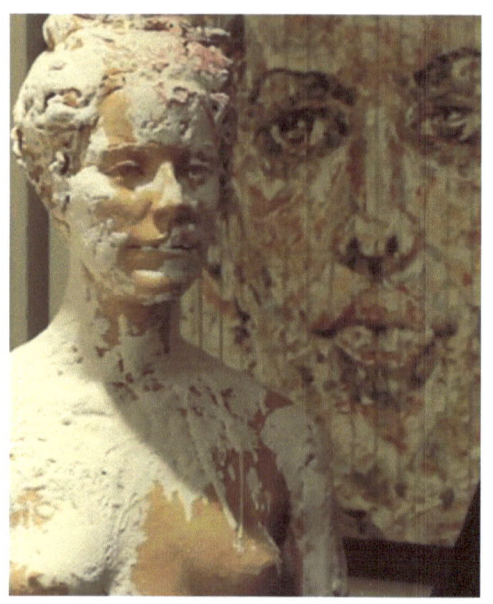

Kathy Venter sculpts realistic ceramic figures from live models. She has developed a style over many pieces that slowly evolves, each piece informing the next. Her work includes impactful narratives from several angles of her life experience. The figures are starkly nude and the clay color is very flesh like. The attitudes on the faces however have a gaze drawn from a more spiritual outlook, influence or story that reduces sensuality and makes them universal people. The splashed surface treatment comes from certain antique artifacts that

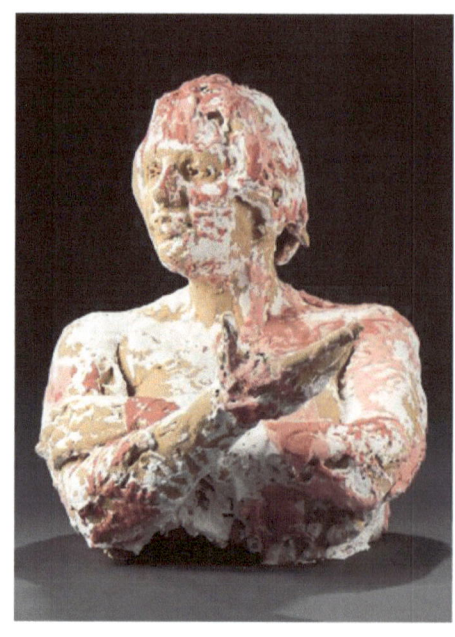

have been created, left to decay and destruction (hence the corrosion) and then preserved and conserved as precious objects. This surface treatment and color brings on a new narrative about time's effects, objects and the metaphor of rediscovery and emerging value to each individual form. Finally she often groups the figures to create psychological situations telling another story of universal emotion, unspecific to one culture.

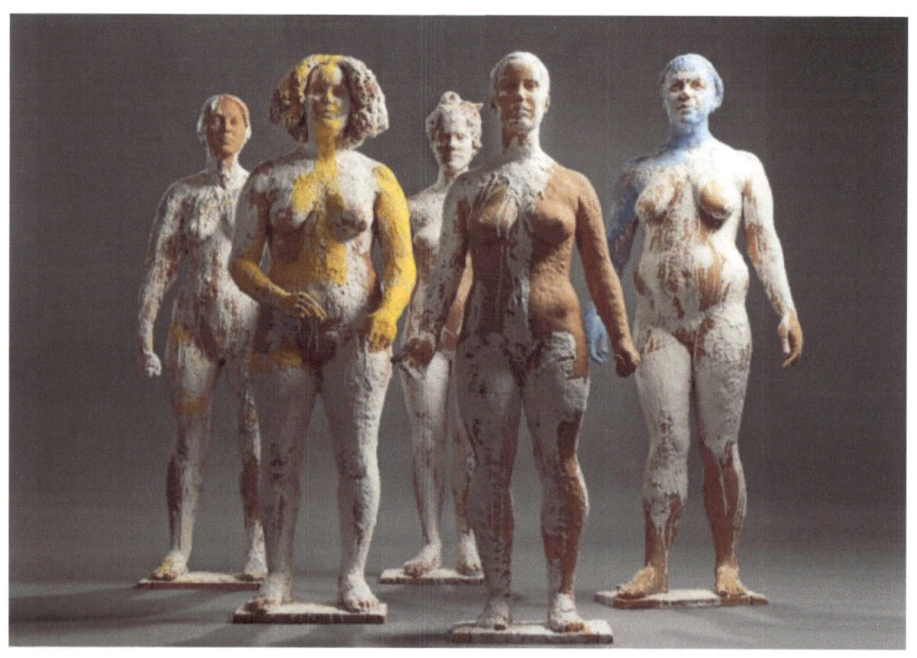
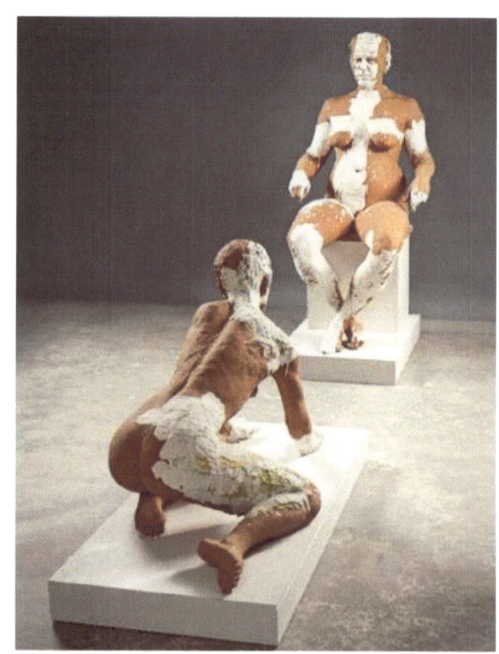

Concept | Technique | Style | Organization Principles | Design Elements

The Range and Assessment of concepts

Art enlightens us. **Concept Art,** without a beautiful object to display, has been valid for over one hundred years. But the field gets murky here quickly and assessing concept art requires deeper tools. Because concept art may not seek beauty, may not focus on craftsmanship and materials, some practitioners think dispensing with beautiful work is modern. *"Just pretty is not art"* is valid but conversely *"Just a concept"* is not art either. Many artisans hide behind craftsmanship and do imitative "pretty" without any depth of concept. Conversely the faux avant-garde wants to ignore beauty and sloppily construct or present concepts that are just not that profound or interesting. The range of human experience is huge and art can convey most of it. Good works usually have a new twist, are profound, unusual or elegantly simple executions beyond the **techniques** and **design elements** employed. Powerful works convey an experience with depth, yet enough mystery to keep intriguing us over time.

Some critique on what is *not* quite up to Fine Art:

- **Technique Driven Art-** (missing a concept) Lots of works are about the process of fabrication and little else. You will see some compositions with fair use of design elements, but many artists with poor composition and no concept conveyed they just built it.

- **Junk Monkeys-** Everybody likes to make animals and monsters out of junk when they learn how to weld. It is rare work that uses elements well in these efforts and conveys more than crude representation.

- **Cute realism-** Many folks like what they can understand. Schmaltsy scenes of children, family, animals and famous people populate many public places. Even when they are well executed of good materials there is often only sentimentality, or no message at all in the work. Often these have little consideration for design elements and composition is lacking.

- **Sentiment and Humor-** (the thin line). Melodrama has no intellectual depth. Obvious, simple emotion has no mystery unless other factors are present, or the work is a rare, profoundly powerful rendering of emotion. Cartoon reduction and Google eyed exaggerations appeal to infants but the mature mind seeks mature subject created from intellect. Humor, coupled with sentiment is done so often and so poorly that it makes creating a humorous work very difficult to pull off as true art.

- **Unoriginal Work-** Many pieces simply imitate others, and often poorly. Those unfamiliar with known styles get fooled by these. Some descriptors for poorly done works:

- **Trite-** Common place, stale, clichéd, tired, worn, corny, banal, overused

- **Campy-** has common tired irony and overused jokes being so extreme that it has an amusing and almost perversely sophisticated appeal. (The Rocky Horror Picture Show).

- **Fine art** does not seek sensation through base humor, stylistic pizzazz, or even extreme detail execution. It may allude to a former style or movement but often points in some new direction.

We assess different types of concepts differently, though we use the same tools. The craftsmanship in a geometric work of stone has little comparison with the craftsmanship in a stone concept piece about destruction, even though they are crafted from the same material.

CAUTION: assessment of art concept may make you disappointed in many works.

Speaking of Art...
Obfuscation through Artspeak- Is art world language a ruse?

Book writers, reviewers, and particularly gallery promoters will use long elaborate descriptions of art, throwing in every cultural, historic and spiritual reference they can think of. "The more you can muddy the waters around the meaning of a work," says an expert on the Language around art, "the more you can keep the value high. "

Here is a typical art show description using extravagant syntax and pure psychobabble:
 "Each mirror imaginatively propels its viewer forward into the seemingly infinite progression of possible reproductions that the artist's practice engenders, whilst simultaneously pulling them backwards in a quest for the 'original' source or referent that underlines the artist's oeuvre."

At the other end of the Artspeak chart is:
 "It kind of looks like a dog, my kid could do that"

With Art Savvey you can now explain what you see. Art doesn't have to be "dumbed down" for you and "smarting up" from Artspeak can be uncloaked.

The last word about being an art snob-
You now have a deep perspective and many tools for reviewing public art. But Beware! Just about the time you have written off certain styles as obvious, tired or trite, you catch a work that is just so fine it astonishes you. Others notice this too, and agree. That is the wonder and mystery of art and concept.

The photos of artworks by page:

Covers: *Renaissance Race* – Tj Aitken

3. Clay bust – unknown, used in Sculpture magazine
6. *Summer Dance* – Barbara Hepworth 1971, *B-Tree II* – Kenneth Snelson, Meijer Gardens Grand Rapids MI
7. *Abstract Figure* – Oskar Schlemmer, Geometric sculpture – unknown, *Vertebrae* – Henry Moore, *Horse* – Raymond Duchamp Villon
8. *Reclining figure* – Henry Moore
9. Butress- State Capital Lincoln Nebraska 1922, *Balzac* – Auguste Rodin,
12. *Vertebrae* – Henry Moore in Seattle, WA
13. Geometric forms – unknown, *Horse* – Deborah Butterfield.
14. *Duchesse De Choiseul* – Rodin 1908, Bonsai tree – unknown
15. *Elbow* – Tony Cragg 2010, Steel form – unknown, *Spider#2* – Louise Bourgeois
16. *Wave field* – Maya Lin 1995 in Ann Arbor MI, *Kinetic Sculpture* – Andrew Smith
17. *Intersection* – Mark Di Suvero, *Cain* – unknown, *Cloud Gate* – Anish Kapoor
19. Paris metro details from 1903, Chrysler building detail NY 1921
20. Primitive female figure – unknown from Mexico, Statue of falcon god at temple of Horus in Egypt, Relief on Church of SS. Apostoli, Naples, Italy – Francois Duquesnoy
21. Wall painting – Egyptian, Venus of Willendorf – 12,000BC, *Discoibol* – Rome 450 bc, Byzantine relief, Dog mask – Aztec, *Vitruvian man* – Leonardo DaVinci c.1490, *The Ecstasy of St. Teresa* – Gianlorenzo Bernini 1652, *Cupid and Psyche* – Antonio Canova, *Balzac* – Rodin, *Unique forms of continuity in space* – Umberto Boccioni, 1913, *Pelagos* – Barbara Hepworth 1946, *Untitled* – Louis Nevelson 1950, *Ale Cans* – Jasper johns 1960, Untitled stones – Andy Goldsworthy
22. Op art sculpture – Victor Vasarely, Tilted *Arc* – Richard Serra 1981, Pop art – Roy Lichtenstein
23. Computer design after Mondrian, *Venus at a Mirror* – Peter Paul Rubens c.1615, *Cube* – YR (created on http://www.PicassoHead.com /?id=79561f2 Nov. 2003), *Mobile-* – Alexander Calder, *Whirlwind in the Thorn trees, 30 miles to San Carlos, Shoulder to Shoulder, She rides a white horse* – by Mark Yale Harris, *Free Thinkers* – Tom Otterness, *Cubi XVII* – David Smith, *Untitled* – Louis Nevelson
24. *Augustus of Prima Port* – c.20BC Rome, *Moses* – Michelangelo 1512, *A Girl* – Ron Mueck, *57 Descending* – Tj. Aitken 2011
25. *Portrait of Georgia O'Keeffe* (Detail) – Marisol Escobar, (Miscellaneous work images)
26. (Miscellaneous work images)
27. *Nelson Mandela* – Marco Cianfanelli
28. *Bus Riders* – George Segal 1962
29. *Ordinary Man* – Zarko Baseski, *Cube* – Richard Walker-, *Draped Reclining Woman* – Henry Moore 1958, *Interlocking forms* – Moore, *Chandelier* – Dale Chihuly (Installation in Venice, Italy), Paintings at the Museum of Modern Art, New York- Jackson Pollock (Photograph: Mary Altaffer/AP)
30. *Christ as the Man of Sorrows* – Pedro de Mena, 1673 Japanese ceramic fish – unknown, Ceramic form – unknown, maison deville en bois (townhouse) architectural detail –unknown, *My Sculpture* – (printed word only) Robert Morris 1972,
31. *The State Hospital* – Edward Keinholz 1966
32. *Telephone Sheep* – Jean Luc Cornec, *Horizons* – Neal Dawson, *Non-Sign II* – Annie Han and Daniel Mihalyo
33. *Saddle* – Janine Antoni
35. Study and detail from *Coup d'Oeil, Phalaborwa (bust), Coup d'Oei, Woman Drawing* – Kathy Venter

| Design Elements | Organization Principles | Technique | Concept |

Other books By Tj.:

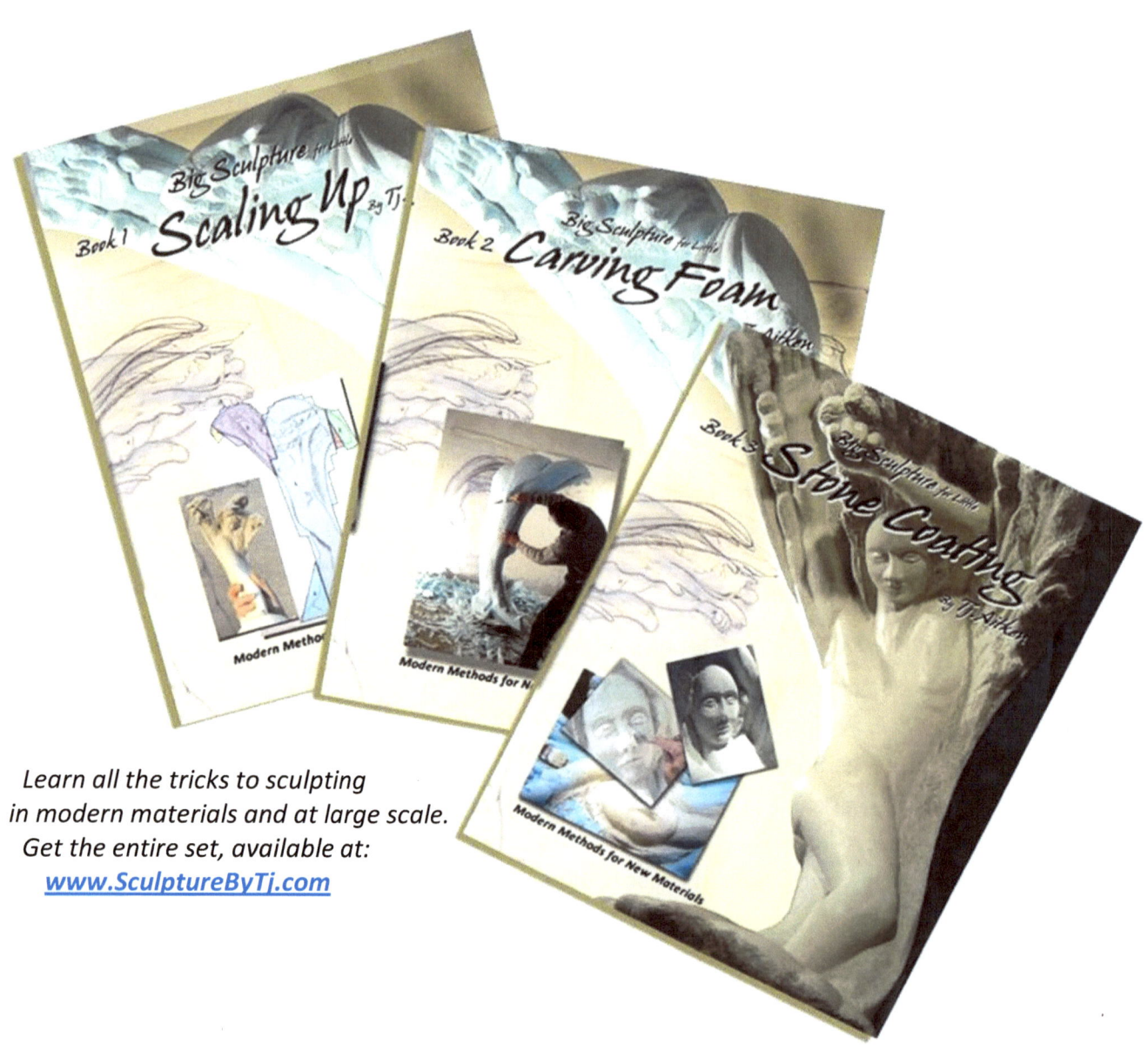

Learn all the tricks to sculpting
in modern materials and at large scale.
Get the entire set, available at:
www.SculptureByTj.com

Concept | Technique | Style | Organization Principles | Design Elements